POSTCARD HISTORY SERIES

Kansas City

IN VINTAGE POSTCARDS

POSTCARD HISTORY SERIES

Kansas City
IN VINTAGE POSTCARDS

Darlene Isaacson and Elizabeth Wallace

ARCADIA
PUBLISHING

Copyright © 2003 by Darlene Isaacson and Elizabeth Wallace
ISBN 978-0-7385-3179-3

Published by Arcadia Publishing
Charleston, South Carolina

Printed in the United States of America

Library of Congress Catalog Card Number: 2003109051

For all general information contact Arcadia Publishing at:
Telephone 843-853-2070
Fax 843-853-0044
E-Mail sales@arcadiapublishing.com
For customer service and orders:
Toll-Free 1-888-313-2665

Visit us on the Internet at www.arcadiapublishing.com

CONTENTS

Acknowledgments

We wish to thank Charlene and Tom Atkin for allowing us to scan their vintage collection of Kansas City postcards. In doing so, they invited us into their home and added colorful commentary that is included in this book. We cannot thank them enough for their kindness, hospitality, and guidance.

The original source of this book is the unique postcard collection of Herbert F. Simon. We wish to honor his memory and remember his love and appreciation of Kansas City, his involved tales of local humor and scandal, and for a true friendship that so many shared.

We also wish to thank the staff at the Kansas City Library and local church personnel for their assistance in reaching into their archives to provide us with the necessary research.

Special thanks go to our husbands, Darlene's husband Max, who helped with research and gave constant encouragement, and Elizabeth's husband Donald, who provided the "tech-help" with the scanning and compilation of this book.

Darlene Isaacson & Elizabeth Wallace

INTRODUCTION

From a private collection of over 400 postcards covering the 1800s to 1950s, Darlene Isaacson and Elizabeth Wallace have selected fascinating images of Kansas City's transformation from cow town to modern metropolis.

Postcards of these and other places not only depict the vibrant lives of Kansas Citians, but also of those who purchased the cards to send them back to curious, concerned relatives in distant towns and cities. As the authors tell us, the "voices" of these travelers recall those of old party-line telephone users, who listened in on the sometimes-intimate conversations of friends, relatives, and neighbors.

The authors also provide captions and commentary that immensely helps to place these images in their historical context. With their attention to detail and their skill in selecting a wide range of impressions of Kansas City life, Darlene and Elizabeth have compiled a collection that is sure to inform and delight all readers. The book illuminates the city's rich and diverse history in a unique, compelling way.

Robert F. Willson Jr. is emeritus professor of English at the University of Missouri-Kansas City. His scholarly work has focused on Shakespeare, but he also continues his interest in etymology. It was this interest that led to his becoming one of the Word Mavens on The Walt Bodine Show, KCUR FM, where he met and worked with Elizabeth Wallace. He is author of several books, including Shakespeare in Hollywood: 1929-1956. (Fairleigh Dickinson University Press).

One

THE COUNTRY CLUB PLAZA AND SURROUNDING AREAS

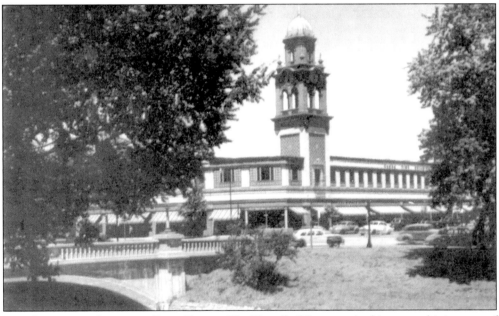

THE BEAUTIFUL COUNTRY CLUB PLAZA. The Time Building seen in this postcard is just one of many fine buildings on the Plaza. The inspiration for this, the nation's first shopping center, came from Jesse Clyde Nichols (J.C. Nichols) who after traveling around Europe on a bicycle became inspired by the wonderful designs he saw in Seville, Spain, but he was also fascinated by other European cities as well. An idea began to grow and he envisioned similar buildings, parks, and fountains in his own hometown of Kansas City. He was an ambitious businessman with an eye for beauty. In 1906, he purchased ten acres of land and plotted out his dream plaza. It would become the first of its kind in America and a model that other cities would use for similar projects. In 1929, the tradition of the Country Club Plaza Light Ceremony began when a maintenance man strung up a few fairy lights over a doorway on the Plaza. By the 1940s, more than 25,000 lights were used and more have been added each year.

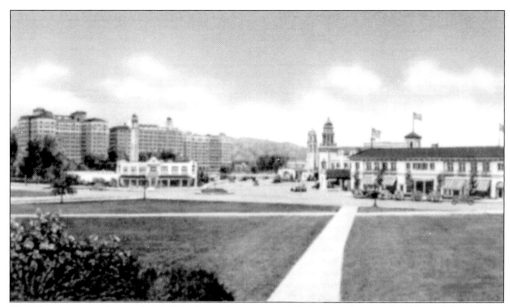

He Walked the Area. J.C. Nichols was known to walk the area he was thinking of developing before he decided on the location of shops, offices, and parks, believing it was the only way to survey the topography. He seemed to instinctively understand the relationship between the American people and their automobiles, and therefore designed the Plaza so that visitors could park their automobiles directly in front of a particular shop or office. The scene on this postcard shows the Plaza at forty-seventh and Mill Creek Boulevard. It is dated 1926, and there is no message.

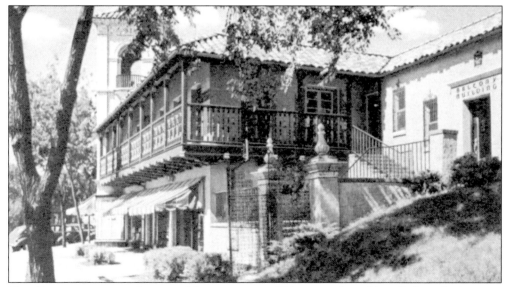

The Influence of a Spanish Marketplace. This postcard could easily be mistaken as a scene from a European city, but yet it sits on a corner of the Country Club Plaza. When J.C. Nichols first conceived the Plaza, some people believed his ideas were too grand for Kansas City and chided his efforts, but he steadfastly believed that a center where people could work, shop, and play would be successful and his legacy lives on today. This postcard is undated.

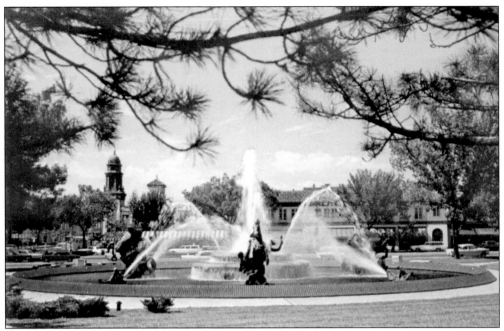

A City of Fountains. In 1910, a Parisian sculptor, Henri Greber, began work on the J.C. Nichols Memorial Fountain. Greber created a masterpiece of a fountain located on the eastern gateway to the Country Club Plaza, complete with a reflection pool 80 feet in diameter, majestic bronze horses, and faun statuary that delivers a constant spray of water high into the air. It is only one of many works of art that provide a constant reminder of the influence of J.C. Nichols, who purchased over $1 million worth of artifacts to adorn the Country Club Plaza.

A Scene on Ward Parkway. Long known for its wide, tree lined avenue and its closeness to the Country Club Plaza, this impressive residential community lies directly south of the business area making Ward Parkway an ideal place to live. Undated, this postcard depicts a man in a straw boater hat and a woman in an ankle-length dress. A young child stands with the couple as they overlook a reflecting pool. The Country Club Christian Church can be seen in the background.

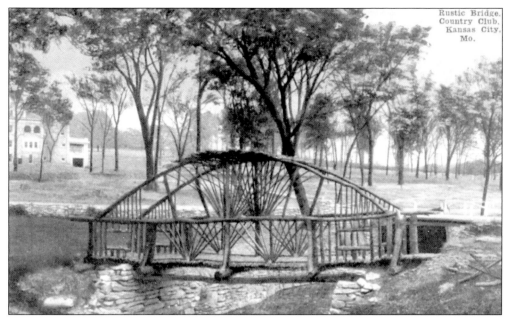

A RUSTIC BRIDGE. A pretty little rustic footbridge is seen on this postcard. The design of the bridge is thought to be one of Sidney Hare's works, as he was instrumental in many of the design layouts for Kansas City parks. This postcard is dated September 10, 1916, and appears to have been sent by a daughter to her parents in Rich Hill, Missouri. The message reads, "Dear parents, we arrived today at 3:30 p.m. . . . had a fine journey . . . will write when I get home . . . Hattie."

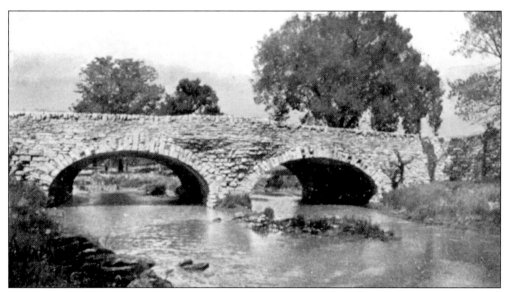

A STONE BRIDGE OVER BRUSH CREEK. In the past, it must have been a favorite place for fur trappers, Native Americans, and travelers who needed to water their livestock as they camped or traveled through Kansas City. At its best, Brush Creek can be a peaceful little stream meandering through the city; however, the situation can change quickly during the spring and summer months, as it did in 1977 when Brush Creek burst free of its banks and the Plaza was flooded. Measures have been taken over the years to correct the problem.

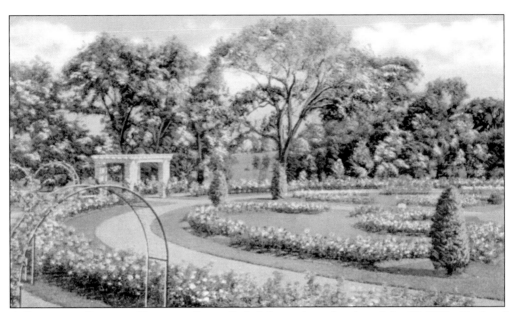

A PLACE TO SIT AND REFLECT. Loose Park is located on the site of the Civil War Battle of Westport. Ella Clark Loose donated the 74-acre park in honor of her late husband, Jacob Leander Loose. This early, undated postcard shows the Rose Garden at Loose Park with many different varieties of roses on display. At the height of summer, the Rose Garden has been used as a backdrop for wedding ceremonies, and the faded rose petals used as confetti.

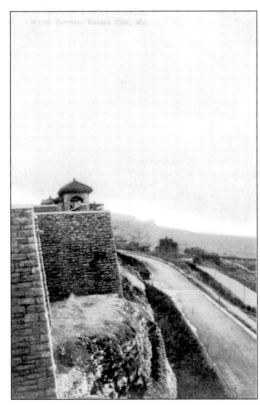

ATOP THE BLUFFS. In 1914, the Park Board published a pamphlet describing improvements that had been made to the area, clearing it of shanties, "And the Kersey Coates Drive, meandering through its length (1.18 miles), above which rise cliff and terraced walls of masonry, characteristic of certain Italian cities, giving a broad panoramic view of the railroad terminals and factories in the West Bottoms, with Kansas City, Kansas, on the hills beyond the Kaw."

13

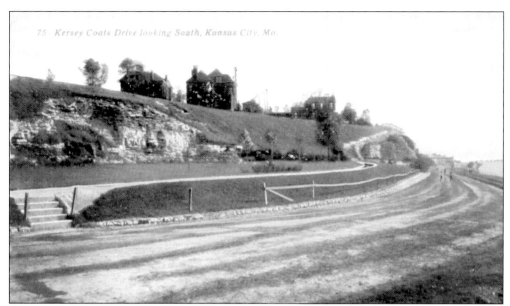

A FORWARD THINKING MAN. The scene shows Kersey Coates Drive looking south as several people stand at the bend in the road. Kersey Coates anticipated the growth of Kansas City and envisioned a type of ring road around the town, but this would not take place until many years later. Kersey Coates was a quiet Quaker from Philadelphia who, with his wife, often took strolls from the hotel down to the river's edge. He built the Coates Hotel, as well as the Coates Opera House that burned to the ground in 1901.

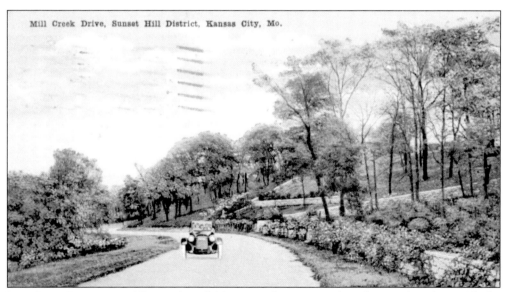

Mill Creek Drive, Sunset Hill District, Kansas City, Mo.

JUST LIKE FAIRYLAND. The sender of this postcard appears to have been quite taken with the area and chose a card that represented their true feelings about Kansas City. This postcard was sent to West Virginia on June 20, 1917, and reads, "This part of the city has rock fences everywhere and in full bloom now with crimson ramblers are honeysuckle vines. Everything is beautiful and like fairy land." Because of the extraordinary beauty of Mill Creek Drive, it was later renamed J.C. Nichols Parkway.

FANCY CAR—NICE HATS. In 1912, there were almost 70 miles of boulevards in Kansas City. In 1913, automobiles were plentiful and increasing at such a fast rate, the police force felt they needed to replace their horse patrols with automobiles to better serve the public. This postcard was sent to Columbia, Missouri. It is dated October 10, 1913, and reads, "Dear Baby, does this picture look familiar. I am by the west dining room window now. I am going to . . . in a few minutes and hope to stay the night. I got the shoes—ok? I hope to hear from you soon. Here is lots of love."

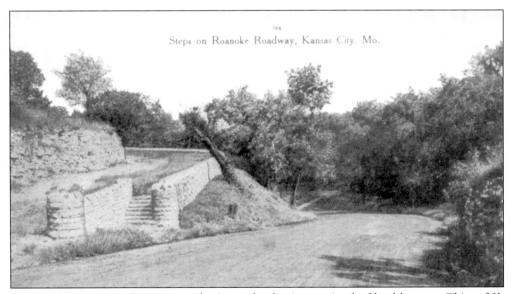

STEPS ON ROANOKE ROADWAY. The Roanoke district consisted of land between Thirty-fifth and Thirty-ninth, north to south, and Holly and Broadway, east to west, and was well known in the late 1800s for its fun-filled pleasure parks and fairgrounds. Several influential Kansas Citians owned stock in the fairgrounds, including Kersey Coates, A.B.H. McGee and Simeon B. Armour, to name just a few. This postcard depicts an unpaved road in a park-like setting.

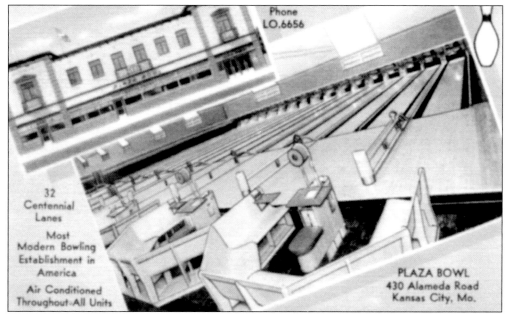

Phone
LO.6656

32
Centennial
Lanes

Most
Modern Bowling
Establishment in
America

Air Conditioned
Throughout-All Units

PLAZA BOWL
430 Alameda Road
Kansas City, Mo.

A Perfect Game. The air-conditioned lanes at the Plaza Bowl made for a great outing for Kansas City residents for not only a bowling date, but also a snack, cocktail, or even a banquet. The Country Club location for the Plaza Bowl made this a popular place for local leagues and helped the tourist trade as well. The high cost of lease space needed for the 32 bowling lanes and a lack of interest caused the bowling alley to close in 1977.

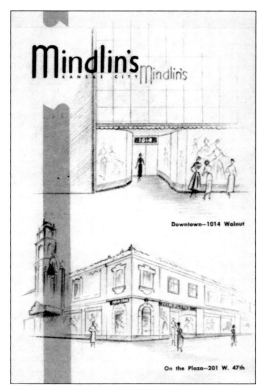

Downtown—1014 Walnut

On the Plaza—201 W. 47th

The Proud Owner of a New Chiffon. In 1932, Mindlin's was a specialty store on the Plaza. Rose Mindlin and her husband, Barnett, came to Kansas City in 1902 as immigrants from Russia. Originally a milliner, Rose's first storefront was in her home at Twelfth and Troost. She provided a special service to her clients as noted on a postcard dated February 2, 1959, that reads, "You are now the proud possessor of a blue chiffon. Come and see me for a fitting. I got it at your price, so it is good to know the right people."

Two

SHAPING THE CITY SCHOOLS, COLLEGES, AND EARLY SCENES

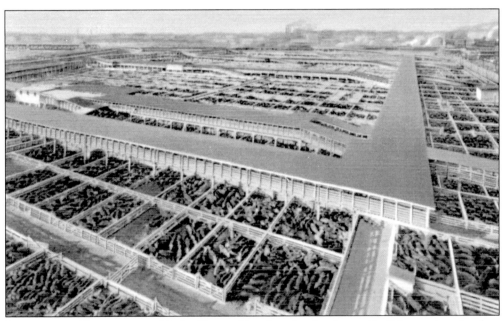

LOCATION IS EVERYTHING. Maybe Kansas City doesn't miss the smell of the stockyards when the west wind blows, but they do miss the revenue that made downtown vital in the years from late 1800s until 1991. The refrigerated truck industry made it more economically feasible to process livestock near production areas. Kansas City was an ideal location from which to ship processed meat to large centers of population such as St. Louis and Chicago. In 1871, the Kansas Stockyards was formed and the Exchange Building was built. Five years later, investments from the Adams family of Boston expanded pens and loading chute areas to the Missouri side so even sheep and hogs could be marketed. Armour and Swift companies opened large packinghouses, as they too anticipated the growth of the area. The economic impact of the stockyards cannot be overemphasized. In 1940, the Stockyards' banks and their buyers consummated many transactions with a mere handshake. The Stockyards brought prosperity to Kansas City as businessmen and visitors stayed in hotels, did their shopping, and sought entertainment in the evenings.

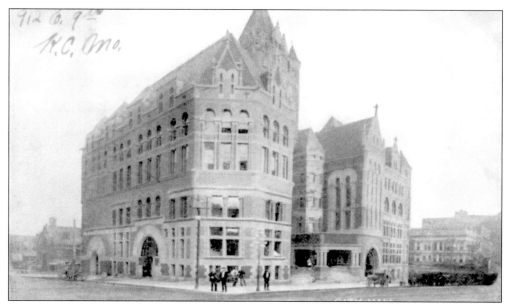

CITY HALL—HEART OF THE CITY. The handwritten notation of address on the postcard's left side indicates the address to be 912 East Ninth Street. Further research indicates this is the first city hall, which was occupied for 88 years at Fourth and Main. The red brick Victorian style building with ornate windows and arches was razed in 1938. Close proximity to the farmers' market made it a busy center of early commerce and pedestrian activity.

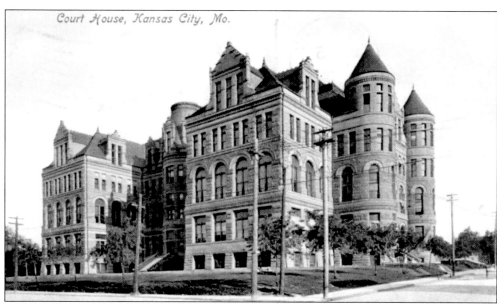

A MIGHTY FORTRESS. Even though the Jackson County Courthouse was built in 1892, this postcard clearly shows electric light poles and wires visible around the block, indicating progress of utilities in the area of Fifth and Oak Street. Features of the new courthouse were native limestone and a slate roof. The turrets gave it a fortress-like appearance. This card is dated 1910, and reads, "I am in the 'Stoddard' work again . . . just as soon as I hear from you I will write you a long letter."

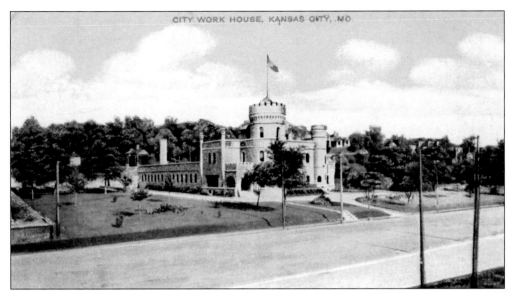

WHERE IS THE MOAT? This postcard shows the Stone Workhouse a castle-like structure at 2033 Vine Street. The long, one story wing was a prison for both male and females who had broken city laws. It was considered a beautiful building despite its use. After declaring the jail unfit for habitation in 1911, male prisoners were moved to Leeds farm, leaving only women inmates to enjoy the surroundings. This postcard ignores any reference to the actual prison. It is dated 1908 and reads, "We did not wash today on account of it raining."

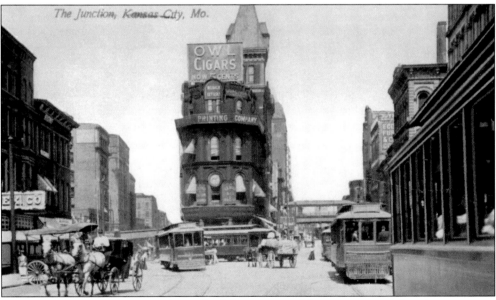

CHANGE IS BREWING. When analyzing the different views of the Junction at Ninth and Main, we can see the change in a few years' time from only horse-drawn vehicles sharing the streets with streetcars, then to horses and cars, and finally just cars alone. We also see advertising on large signs and can note businesses that lasted well into the late 1900s, such as the Palace clothing store. The wide awnings on most businesses protected the many pedestrians from extreme weather conditions. This postcard is dated 1911, and reads, "I arrived OK but very tired."

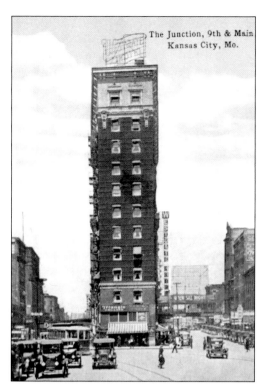

The Junction, 9th & Main
Kansas City, Mo.

THE JUNCTION—MOTORIZED. This scene shows an astonishing change from horse to automobile transportation. There is not a single horse in sight and even foot traffic seems to have diminished. Notice the same model of cars in a row at the curb. This postcard is dated 1922, and mentions that the sender is used to taking the train for long trips, "I leave tonight for Nebraska City and expect to be in A. Lea. Tuesday morning and we think, will layover in Nebraska City on Sunday and Omaha on Monday. Too bad the night train is off."

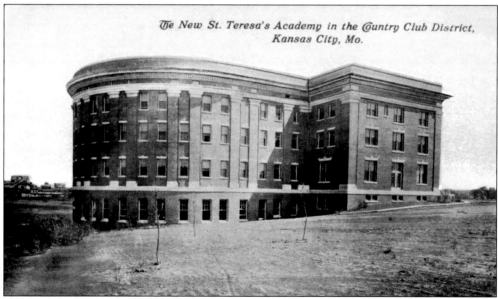

The New St. Teresa's Academy in the Country Club District,
Kansas City, Mo.

THE END OF THE LINE! This would truly describe the location of St Teresa's Academy when they moved from Quality Hill in 1910. The Sisters purchased 20 acres at Fifty-fifth and Main for $40,000. CSJ Nancy Kennedy reveals that there were no neighbors, paved streets, or electricity when the boarding school opened. Students lived on the second floor, while nuns resided on the fourth floor where narrow windows let in limited light. St Teresa's became a four-year college from 1940 to 1962, then moved south to become Avila College.

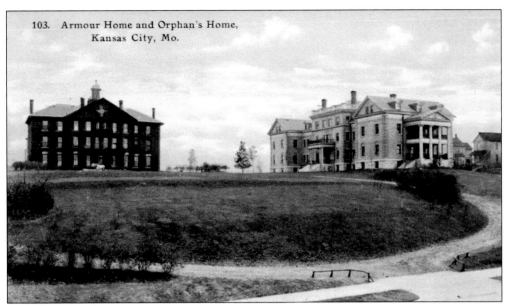

103. Armour Home and Orphan's Home,
Kansas City, Mo.

A Place to Call Home. The Women's Christian Association that began in 1870 was instrumental in the building of the Gillis Orphans Home. They were committed to providing a safe haven for orphaned children and to "relieve the needy and distressed in this new and struggling city," a local newspaper reported. This postcard is dated December 24, 1911, at 8:00 p.m., and the message reads, "Merry Xmas and Happy New Year to all. Otto."

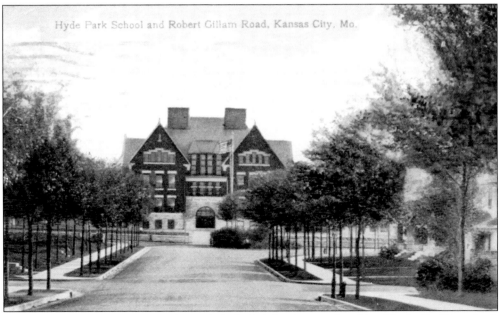

Hyde Park School and Robert Gillam Road, Kansas City, Mo.

A New Student. A new recruit to Hyde Park School wrote her friend in Joplin, "I am back in KC and have been here since Thursday. Let me hear from you soon, Nora." Hopefully she was included in the playground events, games, and sports so promoted by Charles S. Parker, the first Principal at the new school. Hyde Park's four-story brick structure replaced Knickerbocker School's eight-room frame building at Westport, at Thirty-third and McGee Streets.

Training Bodies and Minds. In 1908, the Jesuits selected a stony area near a grove of woods and called the site "Rockhurst." The first school was opened in 1914 with three Jesuit faculty. Its stated goal was to offer courses to train men in every aspect, not just their minds. Athletics was an important part of the curriculum, as was setting academic goals, building strong bodies, and educating the students in classical studies. Mason-Halpin Field House on Bourke Field, located at 5209 Tracy, and was the site of many team events and celebrations.

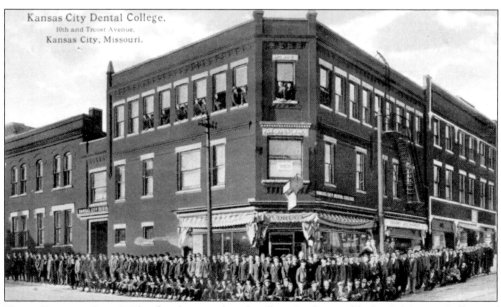

Need Dental Care? The first known dental college in the world, the Baltimore College of Dental Surgery, was opened in 1840. The American Dental Association was not started until 1859, so Kansas City was fortunate to have two colleges, Western Dental College and KC Dental College, by the late 1880s. By 1919, the two merged their colleges and became Kansas City Western Dental College, which built a new facility in 1923 at Tenth and Troost. The college formally affiliated with University of Kansas City in 1941.

Benton School, Kansas City, Mo.

DISTINGUISHED ALUMNI. More famous than the Kansas City Art Institute building itself are its former students, entertainment giants Walt and Roy Disney. Walt's family moved from Marceline, Missouri in 1911. Walt was only nine years old when his father purchased the Kansas City Star newspaper route and enlisted his boys to work deliveries at 3:30 a.m. Walt was rewarded with Saturday drawing classes at the Art Institute. He later graduated from the Kansas City Art Institute and joined a Kansas City company where he helped make cartoon advertisements—the rest is history.

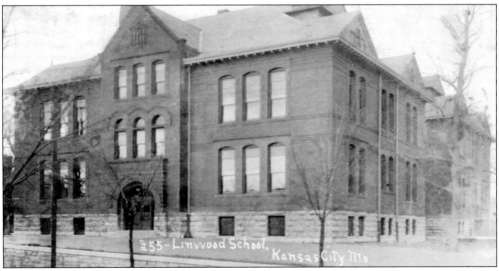

A LEARNING EXPERIENCE CONTINUES. In 1955, the new Linwood School built a modern structure with an $18 million bond issue, on the grounds of the original Linwood School. During its first year in operation, it became an integrated school. The original, one-frame building, known as County School Number 6, was built in 1840 at the corner of Linwood and Woodland, and held twenty-five students. The Kansas City district annexed the school in 1890 and added three large additions to accommodate 1,039 pupils by 1923.

HOW WOULD YOU LIKE TO GO TO THIS SCHOOL? In 1912, there were 72 public schools in Kansas City. The sender of this postcard suggests that the new Central High School located on Eleventh and Locust would be a good choice to a young woman living in Ohio. The postcard is dated 1910, and reads, "How would you like to go to this school? King hasn't had anyone to take him walking or play with since he left you and Cleo."

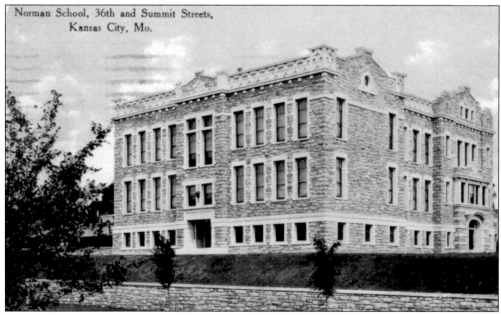

THE EMPHASIS WAS NOT ONLY ON ACADEMICS. The Norman School faculty believed in building strong minds and bodies. Kansas City was the first city in the country with a permanent system of physical education in 1886. The school's beautiful hardwood floors and wide staircases were built in the Coleman Park area for students from the affluent homes bordering the park-like drives. Indeed, this postcard, dated 1914, reflects this ambiance. It reads, "We look for your mother this summer and will be so glad to have her. We have such a nice cool place."

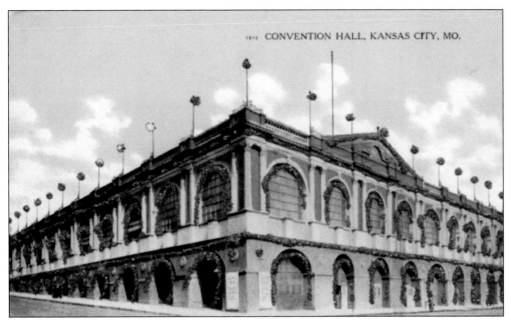

THE CITY'S GROWTH DEMANDED A CONVENTION HALL. When William Rockhill Nelson took his plea to the public in 1893 via the Kansas City Star, he knew the city's need for large facilities for conventions and concerts. The Commercial Club Committee was so successful in fundraising that on opening day, Feb 28, 1899, the citizens had subscribed the entire $225,000 necessary to build the hall, making it a debt-free enterprise. Famous John Phillip Sousa had both afternoon and evening concerts at the hall, and in 1900, the Democratic Party chose Kansas City for their national convention.

KANSAS CITY PRIDE. After a fire destroyed the first convention hall on April 1, 1900, the people of Kansas City went into action. Pride was at its peek when the city responded to inquiries whether they could rebuild for the July 4th National Democratic Convention. They came back with a resounding "Yes!" Shifts of craftsmen worked round the clock in an effort to complete their task. We see on this postcard the convention that nominated William Jennings Bryan for President. No history of early Kansas City omits this story, for it was truly the city's finest hour of cooperation.

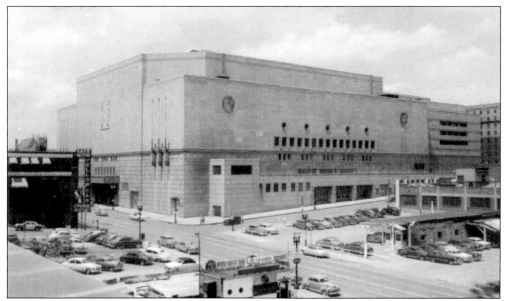

A New City Center. The new auditorium was built in the 1930s when stockholders of the second convention hall gave $725,000, the city issued capital bonds, and the U.S. government gave a grant from the Public Works Administration. Depression economics made unemployed men available for the massive work force. Built with cement furnished by the company of political boss Tom Pendergast, it covered an entire square block from Thirteenth to Fourteenth and Wyandotte Streets. The main arena could seat over 15,000 people.

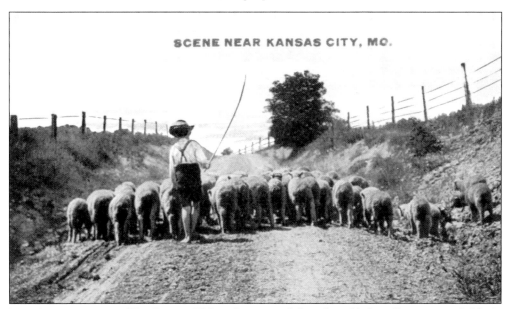

The Shepherd and His Sheep. This early postcard describes this bucolic scene, probably in the late 1800s because only wagon wheel ruts are visible in the roadbed. Visible are barbed wire fences, and perhaps this little boy is herding his flock to a nearby field where there are "greener pastures." Local agriculture was an important factor in aiding the economic development and growth of Kansas City in the late nineteenth and early twentieth centuries.

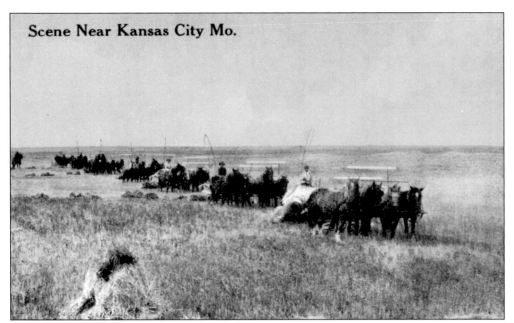

Scene Near Kansas City Mo.

WHEAT HARVEST. Note wheat farmers cooperating to harvest crops. The farmers used long poles, which held twine that tied the sheaves as they came off the reaper. In the foreground we see bundles stacked ready for threshing. See the strong draft horses that worked the harvest. This postcard is dated 1914, and reads, "Dear Grace, tell Ella if you don't think she will get to make my dress I won't go down town this week and get the lace . . . will wait until next week. It is raining here this morning and it is washday. How did you like your . . . dress. Love to all."

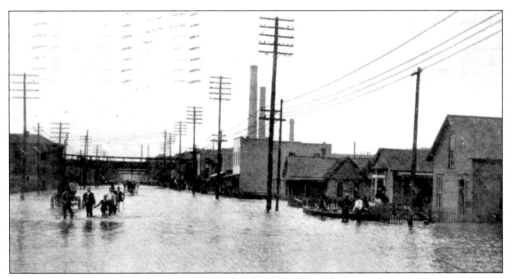

HEARTBREAKING SCENES. A Kansas City flood scene in June 1908, in the West Bottoms district. A flood victim writes, "We are at home again but haven't got our goods at home yet, the water was only thirty-two inches in our house and it is time for me to go to work." Indeed, it was the working class who lost water supplies, electricity, and natural gas as well as loss of life when these floods came to the West Bottoms. Union Station was relocated in 1914 to south of downtown because of frequent flooding.

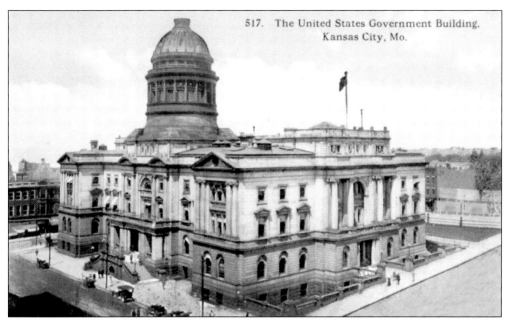

517. The United States Government Building,
Kansas City, Mo.

AN ARDUOUS TRIP. The U.S. Government Building is pictured in the foreground. The postcard is dated 1913, and reads, "Hattie, we missed our train 5 minutes but can't get another out at 10 o'clock. Mildred sick, but will have her doctored up at home. Hot and dusty trip so far and we are both worn out. Love M."

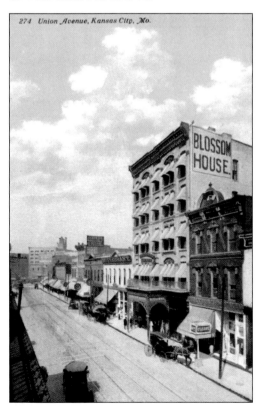

274 Union Avenue, Kansas City, Mo.

A BLOSSOM OF A HOTEL. Major George Blossom opened the elegant Blossom Hotel in 1882. It was located at 1048 to 1050 Union Street in the West Bottoms. This postcard is dated July 21, 1911, and there is no message. When Union Station opened, traffic at the Blossom Hotel dwindled and it was razed in 1915. Other businesses flourished such as the Katz Drug Store. Isaac Katz and his brother Mike moved their business downtown and opened a general store and even hired a pharmacist. Later they were called the "cut-rate kings" of Kansas City and sold everything, even monkey's for $82—reduced to $79, of course.

A Chapel for Prayer. The National College for Christian Workers Chapel was named in memory of Ruth Kresge, who donated the first $25,000 towards the chapel. This 60-acre campus was established at Truman Road and Van Brunt Boulevard when Kansas's Fisk Bible Training School closed, and the Women's Society of Christian Service of the Methodist Church acquired the property to train deaconesses, church secretaries, choir directors, and pastor's assistants. It became the home of Saint Paul School of Theology from 1963 to 1964.

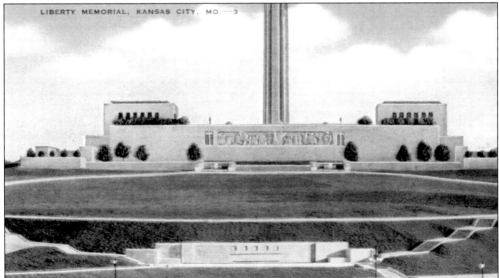

Honoring Those Who Served. It seems like a naïve thought today, but the survivors of World War I actually believed at the signing of the Treaty of Versailles in 1919 that they had fought their last war. Therefore, when nationwide celebrations and fundraising ended on November 5, 1919 pledges totaled more than $2 million. After a national competition, H. Van Buren Magonigle's design was chosen for a complex that included a tower and museum. At the dedication in 1921, Vice President Calvin Coolidge, Allied war leaders, and thousands of others attended.

HIGHER LEARNING. This beautiful postcard, dated February 1947, notes that the college has an enrollment of 2,000 students. The beginnings of the University of Kansas City were built with money and land donated by the aging philanthropist, William Volker. Ernie Newcomb is known as the father of KCU. He worked for three years writing a charter, and in 1933 the University opened with 268 students and a faculty of 18. The new university incorporated liberal arts, law, and dentistry schools. In 1963, it merged with the State University system.

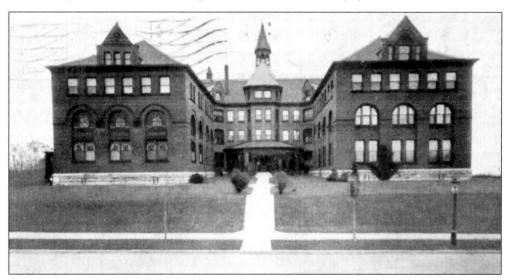

ON THE FINAL DAY. The day before Nathan Scarritt's life ended, he traveled to St. Louis to address the Methodist Women's Board of Foreign Missions, offering land and $25,000 to build this school to educate missionaries. Scarritt, an ambitious millionaire from real estate holdings in both Kansas and downtown Kansas City, was a Methodist minister who had come to teach at the Shawnee Indian Mission in 1851. He founded Westport High School, but moved his family to a log cabin overlooking the Missouri River when danger arose during the Civil War.

STORY TIME IN THE LIBRARY ROOMS. A favorite story at night might have included a true story of the Sisters of Loretto, who traveled by wagon train from Loretto, Kentucky, June 27, 1852. Hardships befell the group when cholera claimed the life of their Mother Superior, and, after they took a wagon train west of Leavenworth, Indians attacked them. Legend has it that one of the nuns died of fright.

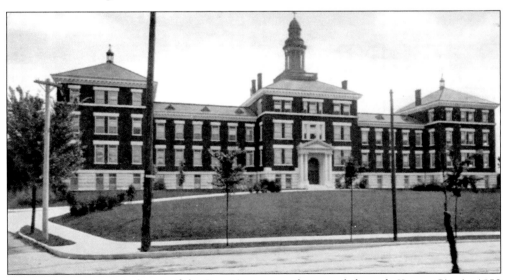

EARLY EDUCATORS. A dream of the Lorettine nuns, who passed through Kansas City in 1852 to spread their faith in the west, was fulfilled when they returned in 1903 and began to lay the foundation of the Loretta Academy at Thirty-ninth and Roanoke Parkway. The beautiful, red brick school was noted for its fine arts department, and accredited with the University of Kansas and the University of Missouri soon after 1906.

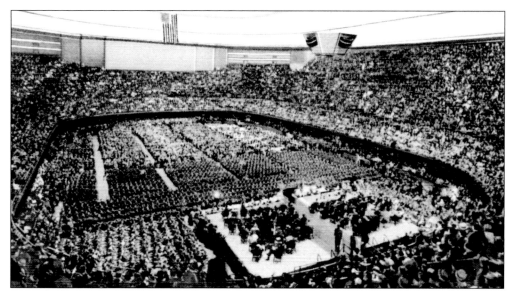

DEDICATED BY PRESIDENT FRANKLIN D. ROOSEVELT. This postcard shows the main arena of the Municipal Auditorium on October 13, 1936, where one can see the actual ceremony in progress. The domed oval ceiling of the main auditorium had no pillars or posts to obstruct views. Centered on the podium is a rostrum designed for the handicapped President, who requested that it be sent to the White House for the inaugural speech in 1941. After the President's death, Kansas City tried to retrieve the podium, but was unable to do so, as perhaps it may have been melted as scrap metal during the war effort.

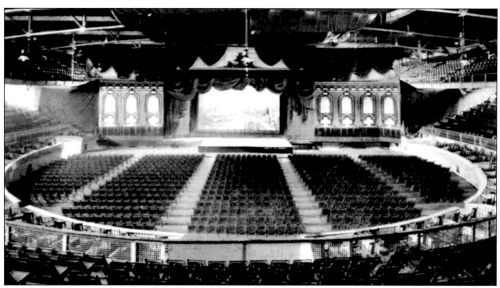

AN ASTUTE MANAGER. Louis Shouse filled the interior of Convention Hall for entertainers such as Enrico Caruso and Madam Nellie Melba, but it was Sarah Bernhart, appearing in "Camille" on February 28, 1906, that broke all attendance records. This hall was a source of pride, with its large elevated seating areas and no obvious supporting pillars. An elaborate stage, complete with heavy crimson curtains serves as a backdrop. It was demolished in 1935 when $725,000 was returned to the city to defray costs of the Municipal Auditorium.

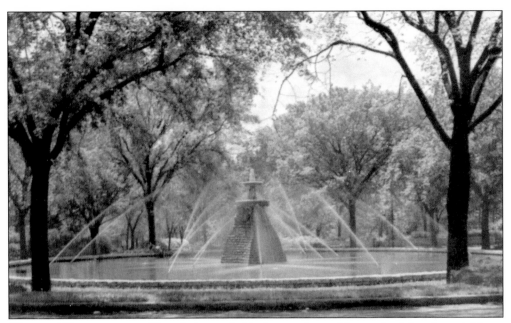

MARBLE MAGNIFICENCE. Though he made his fortune in smelting and mining, August Meyer was a naturalist at heart. His love of the finer things in life shone through as with the Meyer Circle Fountain on Ward Parkway and Meyer Boulevard. As the president of the first Board of Park Commissioners, he enlisted the landscape architect George Kessler to lay out plans for parks and boulevards from Cliff Drive to Meyer Boulevard, southeast and east to Swope Park. Vandals destroyed the marble figure, but it was later restored.

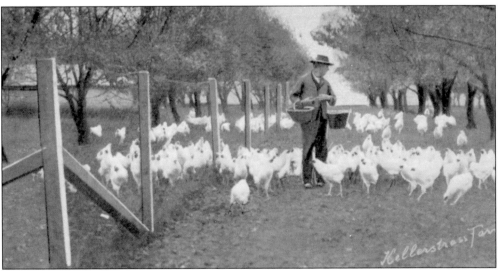

LITTLE CHICK HERE, LITTLE CHICK THERE. This agrarian card shows the "Crystal White Orpington" chicken, a breed which was originated at Kellerstrass farms. This postcard writer indicates he had visited this farm on December 1, 1910. It is likely that he attended an exhibition held in Kansas City, Missouri from November 28 to December 3, when the Missouri State Poultry Board honored Ernest Kellerstrass for his role in the organization of the show, and his successful efforts in poultry breeding.

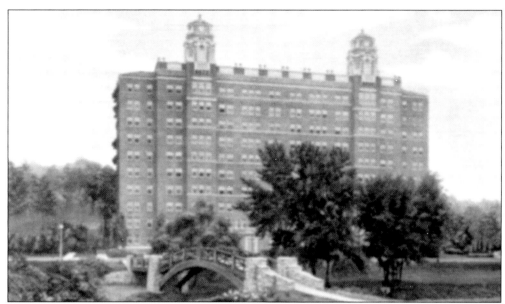

A Prestigious Address. In the mid 1920s, George Miller and Guy McCanless joined forces to build three of the most impressive apartment complexes in Kansas City. The Villa Serena, Riviera, and the Locarno apartments. This postcard shows an early scene of the Locarno although it is undated and there is no message. The apartment complex was within easy walk of the Country Club Plaza, yet had quick access to streetcars and the downtown area for further shopping and banking facilities.

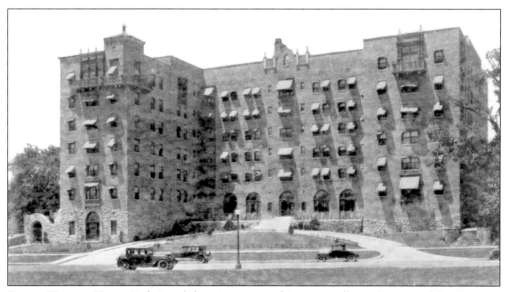

Room With a View. Park Lane's location was within easy walking distance of the Country Club Plaza. From the beautifully designed entrance of Park Lane, residents viewed a small stream that emptied into Brush Creek from Mill Creek Park. J.C. Nichols Parkway was named in his honor, replacing Mill Street Parkway. This postcard, dated September 22, 1933, was sent announcing a meeting of the "Moment Musical Club at the home of Mrs. Fred Schell, 6242 Swope Parkway."

Three

A PLACE TO STAY
AND RELAX
KANSAS CITY'S FINEST HOTELS

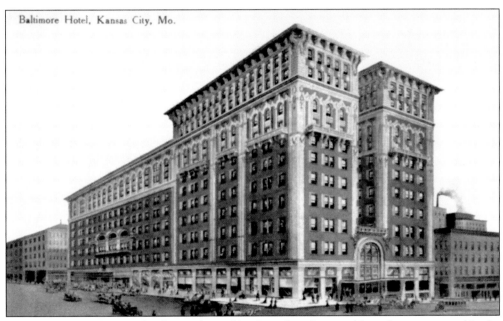

Baltimore Hotel, Kansas City, Mo.

FIVE STAR RATING. Hotel Baltimore's combination of opulent marble and onyx was used in the block-long lobby. The highly decorated, rich tones led to its nickname of Peacock Alley. A tunnel leading to the Willis Wood Theatre was named Highball Alley because it passed through a bar and men's smoking area used during the theatre intermission, and some never returned for the final act. Society loved the ambiance and location for almost 30 years after its opening in 1899. In 1900, the Baltimore was the second largest hotel in the country outside of New York. Multi-story additions were added to the hotel, designed by architect Louis Curtiss, for the Thomas Corrigan estate, the Kansas City streetcar magnate. Hotel Muehlebach merged with the Baltimore in 1919. No other hotel of its day was ever as luxurious. It is still possible to see Carrara marble columns from the hotel's Pompeian Room near Wenonga and Tomahawk Road. This postcard, dated January 21, 1911, was sent to New York. The message reads, "We arrived at 7:30 this morning, it is quite cold here and trying to snow. Hope you are well and having a good time."

DINNER AND THEATRE ANYONE? The Blue Goose restaurant in the White Hotel was located near the Orpheum Theatre, and therefore had easy access to the Kansas City nightlife district. The waiter's formal attire would correctly depict the upscale setting. When the White Hotel first opened in 1912, it was the biggest and brassiest restaurant on West Ninth, but its glory days ended during the prohibition era in the 1920s, when the Blue Goose was turned into a speakeasy.

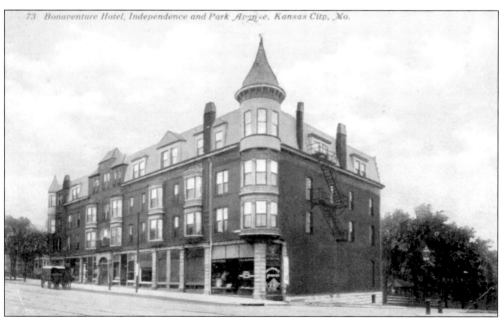

A FORMAL GREETING. A horse and buggy wait outside the Bonaventure Hotel located at 2307 Independence Boulevard. The hotel was built in 1866 and was a four-story building with a distinctive spire that could clearly be seen. This postcard is dated 1914, and appears to have a rather formal greeting. It reads, "My dear, this is from a friend that . . . of professional. I'm well and hope you the same. I am doing well, how is your Mother. Mamma was over to see and was glad to, so goodbye. Mr. Williams." The postcard was sent to Marrie on Washington Street.

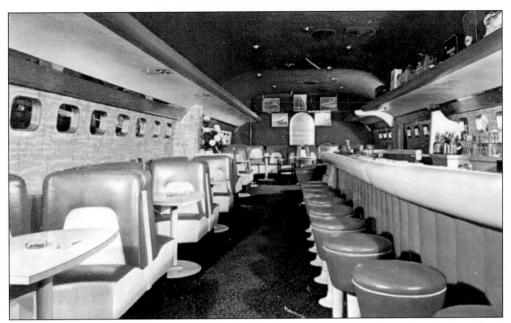

READY FOR TAKEOFF! The postcard indicates this theme restaurant was located in the State Hotel and was called the "Jet Lounge." The State Hotel was next door to the Phillips Hotel at Tenth and Baltimore Streets, and both were natural destinations for business travelers. Note the attention to detail with the airline shaped windows, curved cabin ceilings, and even the starlit sky. This postcard is not dated but states "Home of the Jet Lounge. 200 rooms—200 baths all air-conditioned. First in the World—First in Kansas City—The Original Jet Plane Lounge."

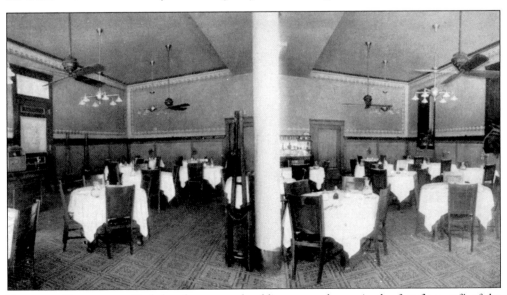

BED AND BREAKFAST. Both hotel guests and public were welcome in the first floor café of the Hotel Victoria. Opening in 1888, it appears quite distinctive and genteel with circulating fans and white tablecloths, and was a teatime favorite for cattlemen's wives who shopped nearby. Dinner hour patrons would likely include the cattlemen cronies of the owner, George Holmes. The wood floors would accommodate men's boots and mud from the unpaved streets.

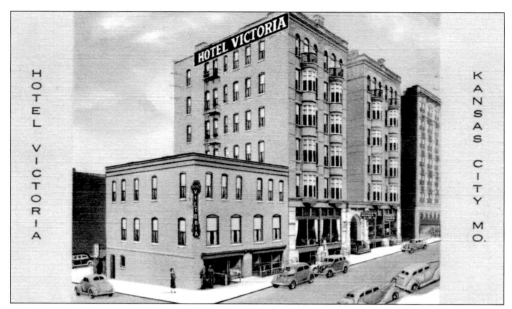

STAY AT THE HOTEL VICTORIA. George Holmes often gave this advice to the cattlemen who were his customers when he worked with his Live Stock Commission Company. In 1886, Holmes' second career was as builder and proprietor of the Hotel Victoria at Ninth Street between Oak and McGee. The hotel was the first to have complete suites that included a bedroom, parlor, and baths in all 240 rooms.

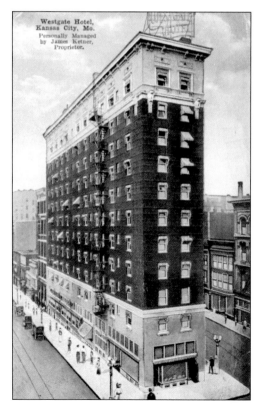

ROOM WITH A BATH. Former Junction Site at Ninth and Main, replacing the Diamond Building, was the new home of the Westgate hotel. Built in 1915, rooms rented for $1.50 to $2.00, all with baths and toilets. This postcard is dutifully addressed to a mother from her son. It is dated 1921, and reads, "Dear Mother, I am starting home trip arrive in Cleveland Saturday, with love, Ray." A flagpole sitter was photographed at the hotel in late February 1927, named "Shipwreck Kelly" who stayed on the flagpole 146 hours in 17 degree temperatures." Demolished in 1954, it is replaced by the Muse of Missouri.

BEST PERSONALITY. A postcard collector, A.T. Cartmell sends a postcard of the Aladdin Hotel to Frances E. Gauger in Milwaukee. This postcard is dated 1949 and reads, "Do you have any PO, capitol, LL or Masonic cards to trade new or used 1 for 1" Located at 1215 Wyandotte Street, the Aladdin Hotel was completed in 1925 and was Kansas City's tallest building at that time. The room rate in 1932 was between $2.00 and $3.50 a day. A popular feature was the underground passage leading to the Municipal Auditorium parking garage.

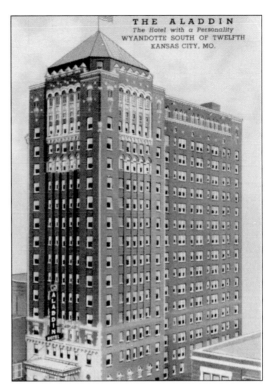

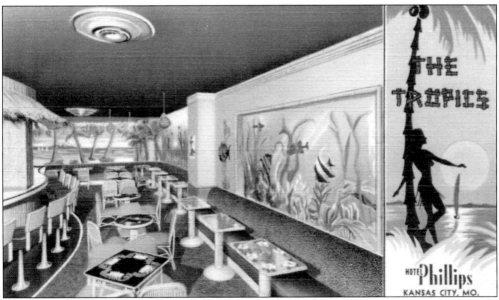

PERFECT HARMONY. Construction of the Hotel Phillips was completed on the site of the former Glennon Hotel in just one year. Not a day was lost to weather, as four radio stations played in work areas craftsmen finished with an unusual spirit of cooperation. Charles E. Phillips, company president, built more than 10 hotels and apartments, naming the Plaza apartments for famous authors. The lobby was unique, using black glass to create a spacious feeling. Restaurants such as the Tropics Bar and Pioneer Room were favored by guests and locals.

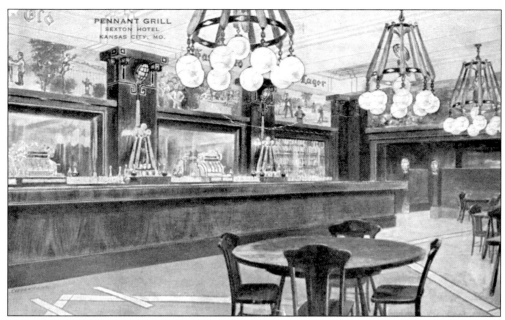

WHERE IS IT? The Pennant Grill operated in the Dixon Hotel's basement from 1911 to 1918. During that time, the hotel changed names from the Sexton Hotel to the Dixon Hotel. It was so confusing to patrons that for many years it was in telephone directories under both names. The baseball theme, carried out in lighting fixtures and murals, was undoubtedly promotion of the president of the Kansas City Blues baseball team, and former Chicago Cubs catcher, John G. Kling. The name Pennant Grill refers to pennants won in 1918, 1923, and 1929.

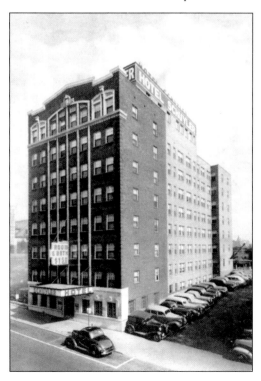

CONVENIENT LOCATION FOR BUSINESS PEOPLE. This postcard of the Schuyler Hotel is not dated but we can assume it was taken c. 1930 to 1940 because of the type of automobiles parked alongside the hotel. Perhaps the cars were all parked by the hotel valet service, since they are all backed up to the side of the hotel in an orderly fashion. The rate was $1.50 for a room with a bath at this convenient location.

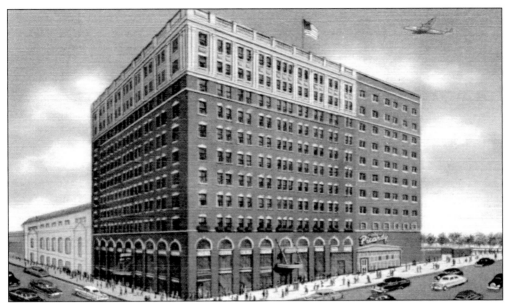

PRESIDENTIAL SUITE. Whenever President Harry Truman came to town, he would always stay at the Muehlebach Hotel. In 1919, Harry's first business, a haberdashery store, was located just across the street in the Hotel Glennon. The tastefully furnished Muehlebach hotel was built by heirs of George Muehlebach, a Swiss immigrant, whose saddle shop was near his farm and vineyard in Westport. The hotel was always home to visiting presidents since it opened in 1915, at a cost of over $2 million.

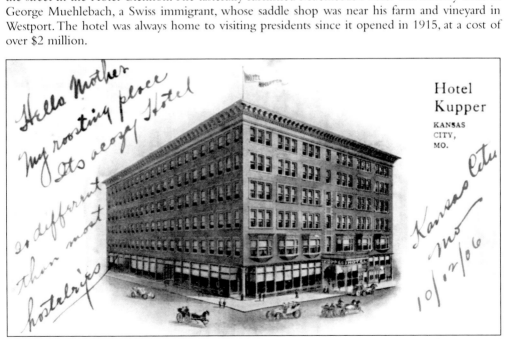

AN IDEAL LOCATION TO SHOP. "I'd like to purchase this please" was a phrase often repeated within earshot of the Kupper Hotel. Its proximity to Petticoat Lane and the shoppers at Emery, Bird, Thayer made it the ideal spot for out-of-town shoppers and locals alike. The hotel at Eleventh and McGee was a favorite of many, as seen in this postcard dated 1906. Early postcards often had messages written on the front and the margins of the card since it was illegal to have anything written except the address on the reverse side.

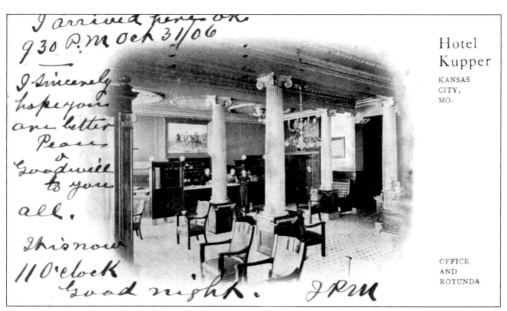

I arrived here on 930 P.M. Oct 31/06

I sincerely hope you are better

Peace & Goodwill to you all.

This now 11 O'clock Good night. JPM

Hotel Kupper

KANSAS CITY, MO.

OFFICE AND ROTUNDA

THE CROWDS IN KANSAS CITY. At the time of the Priests of the Pallas parade, a Kansas City Star reporter described what effect the parade had on the local hotels in an article on October 5, 1910, "Never before, it is said, have there been such crowds at the Kansas City hotels as now. At the Kupper, cots are being used in the writing room, the halls and lobby, and long lines of applicants for a place to sleep have been turned away."

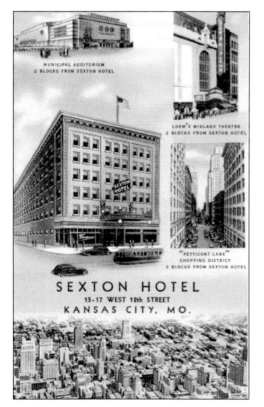

MUNICIPAL AUDITORIUM
2 BLOCKS FROM SEXTON HOTEL

LOEW'S MIDLAND THEATRE
2 BLOCKS FROM SEXTON HOTEL

"PETTICOAT LANE"
SHOPPING DISTRICT
2 BLOCKS FROM SEXTON HOTEL

SEXTON HOTEL
15-17 WEST 12th STREET
KANSAS CITY, MO.

HEART OF HOTEL COUNTRY. It has been said that when the Muehlebach Hotel was built in 1915, there were four large hotels located at Twelfth and Baltimore. This postcard shows a long view of the original Sexton Hotel built in 1907. Expansion and a name change from the Sexton to the Dixon Hotel took place in 1912. But obviously, it was still known as the Sexton Hotel for many years because this postcard shows the Municipal Auditorium that was not even built until the 1930s and includes a modern city skyline. More than one person has been confused with the name change.

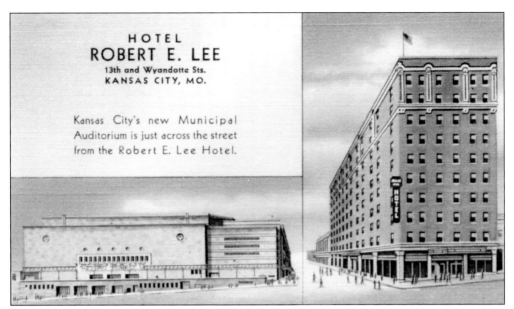

FALL OF THE ROBERT E. LEE HOTEL. Robert E. Lee was only 29 years old in 1954 when, during demolition, the Eighth and Ninth floors collapsed into the street, pelting two passing motorists and narrowly missing four pedestrians. Fortunately, no one was injured. The hotel's location was on Wyandotte next to the Municipal Auditorium. This postcard was sent to Texas on Aug 29, 1938, and reads, "Dear Jack & Cora, Lil and I are at this Hotel. If you are up this way drop in & see us. I will see the Dr. tomorrow. I am melting with heat."

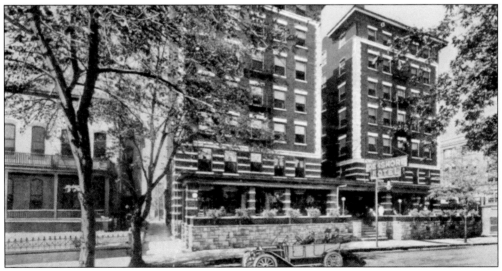

CHALK DUST. This postcard shows the Densmore Hotel at Ninth and Locust with a sedan waiting at curbside. The women in the car wear elaborate hats and dresses. The hotel was home to many transient tenants during its early years, but Catherine Gepford remembers it in the 1940s as a residence for retired schoolteachers, including Hortense Mason, renowned first grade teacher and reading expert. Meals were served in the hotel, but a favored lunch or dinner destination was at the Ormond Hotel across the street. Nearby was the Bluebird cafeteria, the first restaurant of the Putsch family. This postcard is dated September 17, 1912.

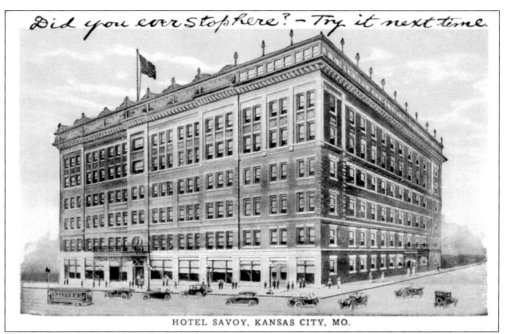

Did you ever stop here? — Try it next time.

HOTEL SAVOY, KANSAS CITY, MO.

NIGHTS ON THE TOWN. Many a cattleman or theater lover would have enjoyed the accommodations at the Savoy Hotel. Built in 1888, the location at 219 West Ninth Street was near Quality Hill, which would have had the Coates Opera House within walking distance. Women were banned from the hotel grill, but welcomed in the formal dining room. This postcard illustration was made after cars joined the horse and buggy for transportation on Kansas City streets.

LIVING HIGH. The Hotel St. Regis, located at Linwood and The Paseo, was an exclusive apartment hotel. The concrete building was built on a high ridge in 1914. The ninth floor ballroom was determined the city's highest point. This luxurious family hotel used French Sienna marble to line halls and parlors. It is no wonder that Theodore Gary, steel magnate, occupied the largest hotel suite. Guests and public alike enjoyed Mrs. Searcy's "Tea Cup Inn."

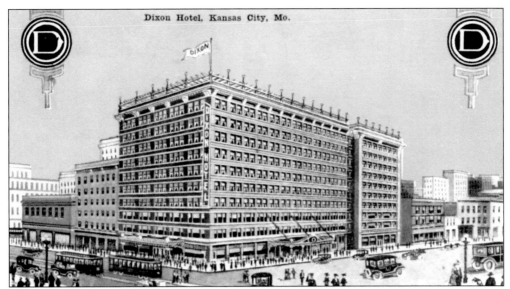

Dixon Hotel, Kansas City, Mo.

JOB RECRUITER. Other hotel guests at the Dixon Hotel were likely to have been cattlemen buyers and sellers. Records indicate they all rested on Simmons beds and Sealy mattresses. The Dixon Hotel was built as the Sexton Hotel. This postcard is dated Sept 2, 1919. It was sent to Mr. W.T. McClutyre in Indiana Harbor, Indiana, and reads, "Been in T. all day & I'm too tired for a letter. On the trail of L-DS teachers but no definite answers yet. Long letter from Vira today. I'll let you know if I do succeed in getting a teacher."

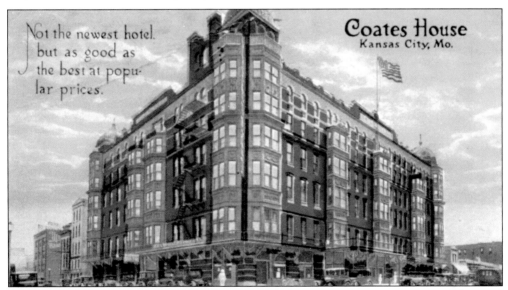

Not the newest hotel. but as good as the best at popular prices.

Coates House
Kansas City, Mo.

FIRM FOUNDATION. Before the civil war, the foundation was laid for the Coates Hotel, but used for cavalry barns and barracks instead. Completed by 1868, the hotel on Quality Hill was located across the street from the Coates Theatre. Kersey Coates, a Philadelphia lawyer who had many businesses in Kansas City, owned both ventures. He started the first bank, was a railroad president, and later opened a shop known as Emery, Bird, and Thayer. This postcard is dated 1924 and reads, "Just saw the wonderful picture 'Scaramouche' at the Royal Theatre . . . Alice Terry appears in the most gorgeous gowns. Yours, Mary."

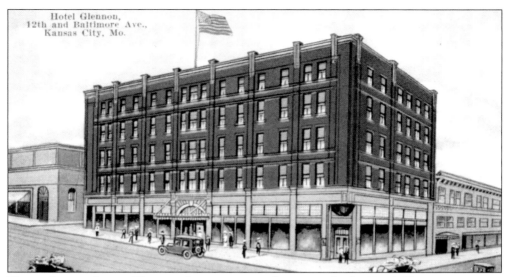

Hotel Glennon,
12th and Baltimore Ave.,
Kansas City, Mo.

HOTEL LEASES SPACE. The most famous tenant to lease space in the Hotel Glennon was Harry S. Truman and his haberdashery partner Eddie Jacobson. After leasing the shop front on November 28, 1919, they operated the shop until the business failed during an economic slowdown following World War I. Even after his presidency, Truman sightings were not uncommon. Robert Londerholm tells of walking along Tenth Street one cold morning when a strong cheerful voice greeted him, "Good Morning, young man." One does not forget a greeting from Harry S. Truman!

A POIGNANT GREETING. The reader can be forgiven if tears arrive when reading this card. Upon examination we can safely determine that an elderly woman wrote it for her son. The stickers added to the front of the card are placed upside down, and the shaky handwriting indicates a frailty that is obvious to the reader. This postcard is addressed to Jerrald Nirfrall at 404 Main Street, Joplin, Missouri, and the message reads, "To my baby from your Mother with love." No doubt the fact that it was never mailed is why it is part of the collection today.

First of Many. State of the art remodeling was implemented at the Midland Hotel, including electricity, private baths, and fireproofing. It opened in September 1888 and was host to Presidents McKinley, Harrison, Cleveland, Teddy Roosevelt, and Taft. Stars from the Auditorium Theatre and Opera House, including Mrs. John Drew and her grandson, as well as Lionel Barrymore were guests. Democratic factions of "Goats & Rabbits" met in separate parlors. Better clientele flocked to the Baltimore Hotel when it opened in 1899. This postcard is dated 1907, and reads, "Dear ... Suppose you have had many a jolly dinner here. Am looking eagerly for your promised budget. Kindest . . .Christine."

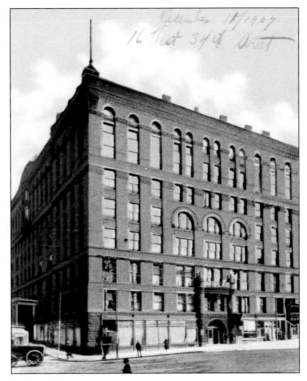

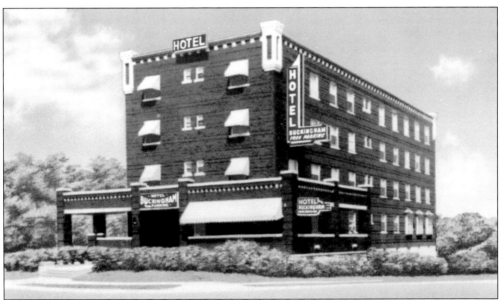

Modest, But Friendly. The Buckingham Hotel at 3045 Forest advertised their residence as a friendly place with reasonable rates. Perhaps not as friendly was the exclusive Bellerive Hotel that opened in 1922. Bellerive guests had packages delivered to their door by a bellman on the service elevator, smelly foods were banned, and four maids were assigned day and night for each floor. One had to imagine that guests at the Buckingham carried their own parcels and turned down their own beds.

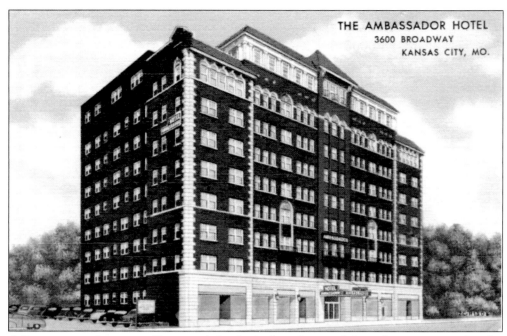

A PRESTIGIOUS ADDRESS. City records for the Ambassador Hotel show that it was one of twelve major hotels and residences Kansas City built in 1925, and that Nelle Peters was the architect of four of them. The hotel and her cluster design apartment buildings on the Plaza are still in use. This postcard is dated January 21, 1959, and reads, "Am kinda tired from the trip in. It was so icy but the wind and snow & sleet blowing made it kinda hard driving. I hope it is going to be nice in the morning when we leave here. Love Dan & Hilary."

SAVOY HOTEL STILL GOING STRONG. This postcard depicts one of the twelve murals created by Edward Holslag that line the walls of the Savoy Grill, Kansas City's oldest operating restaurant. Amazingly, the grill is still in operation and the murals are intact, although some are covered with ducts for heating and cooling. Each mural depicts the long journey from their departure from Westport Landing, to the west along the Santa Fe Trail, ending with their arrival in Santa Fe. The murals are thought to have been completed early in Holslag's career, probably when the Grill was built in 1903.

Four

Kansas City Leisure
Restaurants and Entertainment

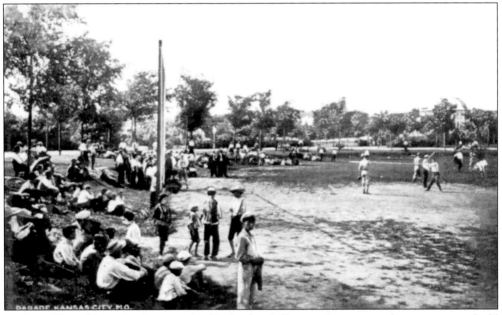

Batter Up. This undated postcard with the baseball game in progress shows young and old relaxing on the grassy slope watching "America's favorite pastime." Casey Stengel, a legendary baseball player and manager, perhaps sat in a similar park and dreamed of a career in baseball. He did eventually become so well-known, that he was nicknamed for the poem, "Casey at Bat." In 1884, Kansas City's first baseball team was called the "Cowboys," but was later changed to the "Blues" in about 1888 to match their blue uniforms. A brewer named George Muehlebach purchased the Blues in 1917 and built a stadium in 1923 at Twenty-third and Brooklyn Street where they shared a lease with a Negro team formed in 1920, called the "Monarchs." The name "glamour franchise" was the label given to this team, because it nurtured players such as Satchel Paige and Buck O'Neill. In April 1947, Monarch's player Jackie Robinson integrated major league baseball when he donned a Dodger's uniform. Owners supported segregation up to this time because they feared financial ruin if they lost revenue from rental fees and gate receipts.

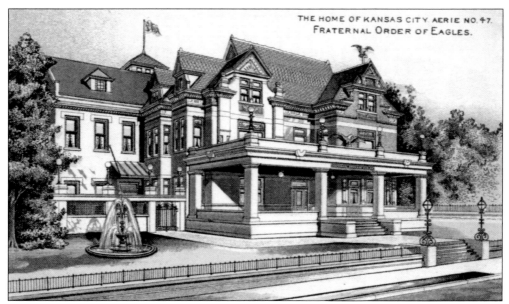

THE HOME OF KANSAS CITY AERIE NO. 47.
FRATERNAL ORDER OF EAGLES.

IT BEGAN WITH A GOOD IDEA THAT SPREAD. That the home of the Fraternal Order of Eagles in Kansas City is known as Aerie No. 47 indicates it was one of the earliest locations of the order—New York is No.40 and Philadelphia is No. 42. The original members were theater owners who quickly resolved a dispute among managers, stagehands, and general theater personnel. They later formed an organization called "The Order of Good Things." This postcard is undated and there is no message.

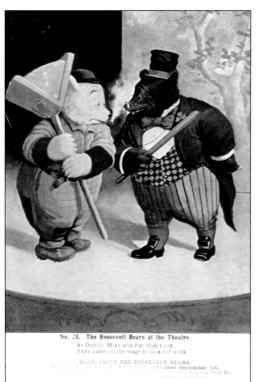

No. 24. The Roosevelt Bears at the Theatre.
"As Dublin Mike and Pat from Cork,
They came on the stage to look for work."

"MORE ABOUT THE ROOSEVELT BEARS."
Published September 1st.
Kansas City Mo.

THE ROOSEVELT BEARS AT THE THEATER. The fascination of the teddy bear is believed to have begun when President Theodore Roosevelt refused to shoot a bear that was tied to a tree in the woods. The President declined to shoot the bear, believing it was cruel and not sportsmanlike. The following day, November 16, 1902, the Washington Post ran a cartoon depicting the event, and thereafter bears were called "Teddy Bears." This postcard is undated but reads, "As Dublin Mike and Pat from Cork, They came on the stage to look for work."

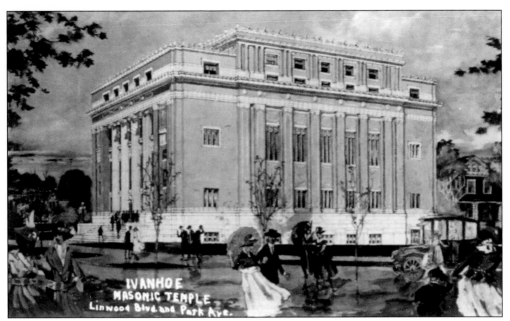

A Scottish Rite. The old Ivanhoe Masonic Temple on Linwood Boulevard is shown on the postcard, along with women wearing long white dresses, fancy hats, and using umbrellas. It also appears to have been raining and windy, since men are shown holding onto their top hats. Several people are on the steps leading to the entrance of the temple. This postcard is dated November 4, 1916, and reads, "Hello Scotty glad to hear that all the folks are well. Aint letr [sic] arrived OK."

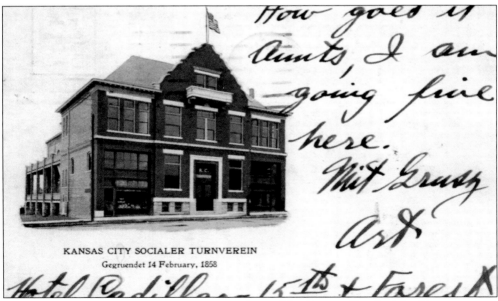

Ten Naturalized Citizens Formed a Club. The Kansas City Socialer Turnverein was founded in 1857 when ten naturalized men of German birth decided to start a club. The club's goal was to help and nurture members and their families become good American citizens. This postcard is dated 1915, and reads, "How goes it Aunts, I am going fine here . . . Art." The card has an inscription, "Gegruendet 14 February, 1858."

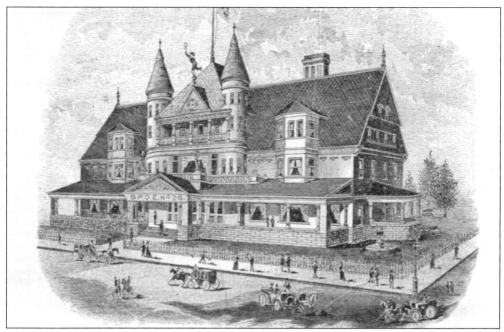

YOU CAN'T MISS IT! After the Elks reassembled the Wisconsin Pavilion from the 1893 Chicago World's Fair at Seventh and Grand Avenue, it was the site of the first national Elks convention held in Kansas City. Membership peaked at 1,000 in 1934. To promote a convention that attracted 35,000, the Elks painted the house a bright yellow color. Complaints of gambling and drinking on Sundays prompted several raids, in the 1940s. This postcard depicts Lodge #26 BPO It is dated 1906, and reads, "Dear Aunt Katie, Arrived here at 7:30 A.M ... had a lovely trip so far. The Elks are taking best care of us. With Love."

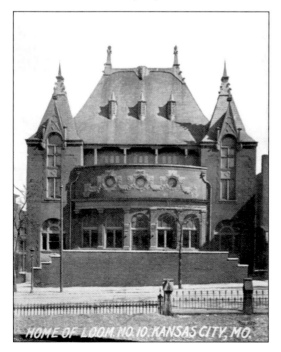

LOYAL ORDER OF MOOSE. The building dates 1897, and was originally built as The Progress Club, a Jewish social club. Later it became known as the Oakwood Country Club. This postcard shows it as the home of the LOOM #10. This beautifully built home perhaps used the architectural skills and workmanship for which the masons are known, because it displays their emblem in the turrets of the house. In 1913, Major A.J. Roof notes the interest in a particular branch, "The order is increasing rapidly in membership and the officers anticipate three hundred active and honorary members before the close of 1913."

A SPORTS-MINDED MAN. The Kansas City Athletic Club was the inspiration of a man in the late 19th century named Arthur E. Stillwell. He was a man of vision who believed in promoting the health and well-being of young men. He developed Fairmount Park between Kansas City and Independence and later formed a Cycling Club that flourished as membership increased rapidly. After World War I, the Kansas City Athletic Club took a new residence at Eleventh and Baltimore where the club continued to grow.

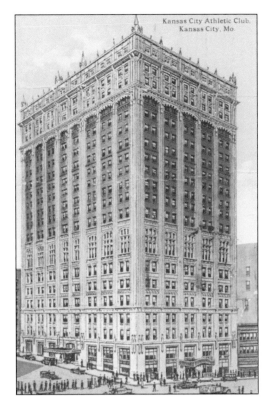

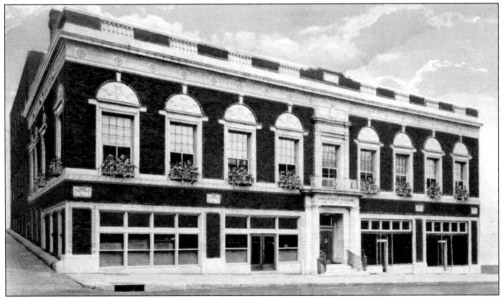

THE OLD OR THE NEW? The first University Club at Tenth and Bluff was absorbed by the Kansas City Club in 1892, but the University Club was soon formed again in 1900 by Sanford B. Ladd, an attorney. In 1906, members leased a building at Eleventh and Baltimore, which was destroyed by fire in 1923. Soon afterward they built this two-story, red brick building at 918 Baltimore, and decorated it with window boxes and vines.

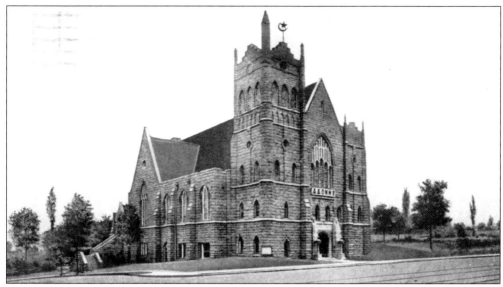

It Looked Like a Church. The Shrine Mosque H-1691 might have resembled a church to some observers in 1912. The elaborate building must have seemed familiar when viewed by spectators at Twelfth and Prospect, which had housed the Fifth Presbyterian Church. However, closer inspection would reveal a crescent and star, Masonic emblems. Some 2,300 members used this lodge until December 1926, when they moved to Eleventh and Central. In World War I, members of the Shrine Mosque organized many activities that continue to this day.

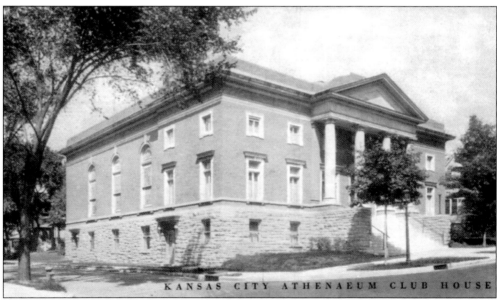

A Women's Club. The role of working women has changed drastically since the first Women's Club members met in 1894, in rented rooms of the music building at Ninth and Locust. Catherine Gepford, a member of the club since 1940, remembers the club's building at 900 East Linwood, when it was used for meetings and luncheons after it was built in 1915. Women joined departmental interest groups for active participation and a strong voice in community and government.

54

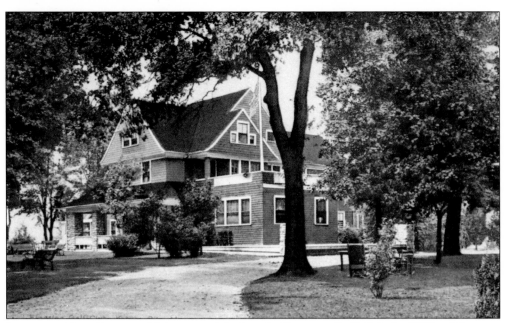

LOCATION FOR SUCCESS. This postcard depicts the Evanston Golf Club. In 1897, golf became popular in the Midwest and most golfers used the Fairmont Park links. Later, a site near Robert Van Horn's home was used until 1905, but when the club leased Colonel Thomas Swope's residence as their clubhouse for 15 years and golfed on a 120-acre tract, membership blossomed and the Evanston Golf Club came into its own. Large stone fireplaces, a ballroom, and even summer residences were available for club members.

OFF TO CHICAGO IN THE A.M. The YMCA hosted many travelers on route to other places. This postcard is dated 1911, and reads, "Dear Folks: We arrived at Kansas City Mo. This A.M. Will start for Chicago tomorrow. We are staying at the Y.M.C.A.—notice the picture. We'll take an auto to see the city this P.M. Etta." The card was sent to South Bend, Indiana.

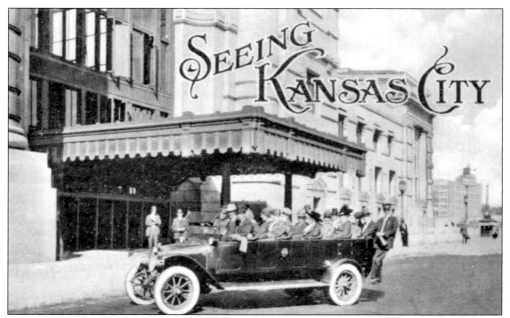

ARE THEY COMING OR GOING? Whichever the case, the open-air transport was certainly one of the first multi-passenger vehicles, and must have been popular on a sunny day. The touring car appears to have picked up passengers at Union Station for a city tour. Note the guide standing on the rear bumper holding a bullhorn. All passengers wear hats and appear to be well-heeled individuals.

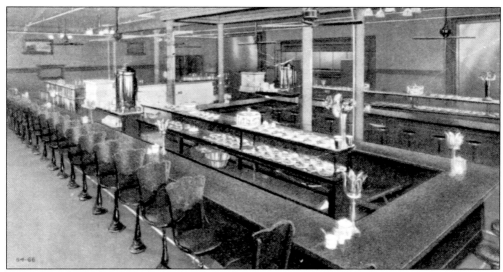

A SIMPLE DELIGHT. Department store luncheon establishments, such as the Dairy Lunch Room at the Jones Store, flourished in downtown Kansas City. Emery Bird's lunches on the mezzanine were legendary too. Nearby, Fred Wolferman's Bakery and Restaurant was also popular. Ann Arensmeier, a shopper from Hamilton, Missouri remembered, "that on their all day shopping trips—first stop, Wolferman's bakery—they would pick the folded apple strudel, packed in cake boxes and checked with the cashier for PM pickup. During lunch, we enjoyed our balcony table overlooking the bustle of shoppers on the floor below."

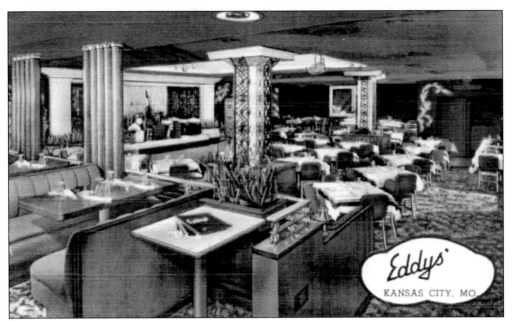

OUT ON THE TOWN. Charlene Atkin shared a pleasant memory, "If you go to Eddy's restaurant and night club on a date, you wore your best bib and tucker." The entertainment may have been a comedy routine or even a magician. Sometimes big-name orchestras provided the music for dancing in between courses of fancy entrees. The location at Thirteenth and Baltimore was important in attracting both local customers and nearby hotel guests.

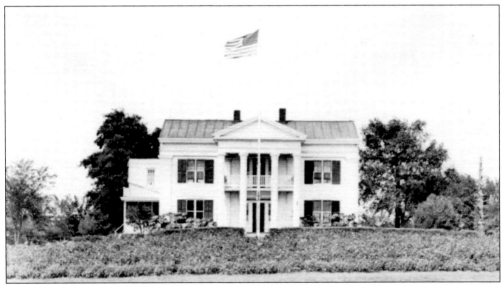

CELEBRATIONS. "The Old Plantation restaurant oftentimes hosted a birthday or anniversary and the good food would warrant a drive out to the restaurant on Highway 40," says Catherine Gepford. "It's beautifully furnished interior with a provincial flair was too expensive for ordinary occasions but many private club meetings, teas, luncheons, or receptions were scheduled other than the evening hours and Sunday dinners." Early proprietors were Karl and Vera Kiekert.

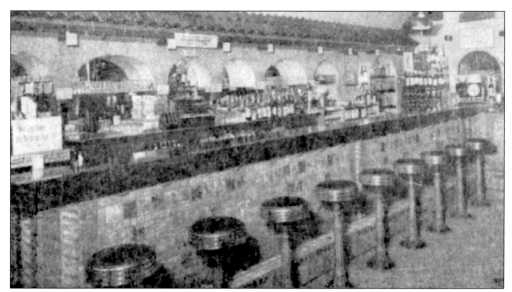

THE WATERING HOLE. This term was often given to restaurants or bars that sold more liquid refreshment than food, and that term could have been used at Maurers' Restaurant. Certainly the exterior photo of this establishment at 1308 Main Street gives that impression. The postcard is undated, but presumably is early 1900s because of its special printing process. It is unusual because there is a photo of the dining room on the back. The earliest cards did not allow either writing or photos on the backs of postcards, but only the address of the recipient.

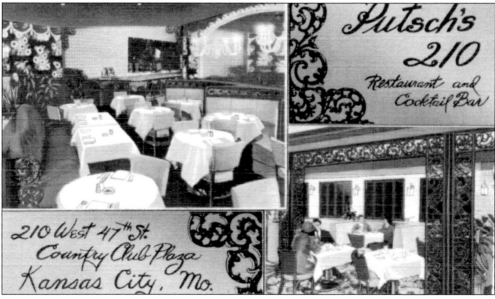

EVENING TO REMEMBER. A first visit to Putsch's 210 was a fantastic night as Darlene Isaacson remembers, "It was great food and wonderful service and considered to be one of the best restaurants West of the Mississippi." J.W. Putsch was introduced to the trade by his parents who moved to Kansas City and operated the Bluebird Café. He and his wife Virginia opened this upscale eatery in 1947 after he returned from the Navy, and subsequently operated both a cafeteria and coffee shop on the Plaza.

58

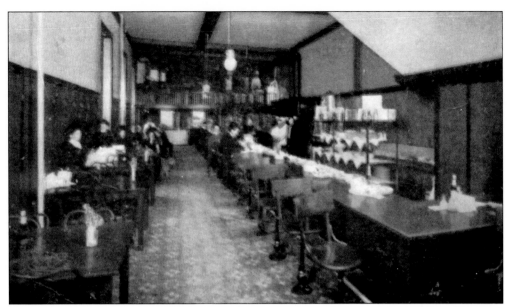

NO YOGURT SMOOTHIE. Teck's Quick Lunch probably catered to clientele of working-class men and women who worked at offices in nearby buildings, and who perhaps stayed at the local hotels. Note the counter with chairs, not stools, so the ladies in long dresses could comfortably enjoy lunch. One wonders how the menu at Teck's would compare to the quick lunches served downtown and at the Country Club Plaza today.

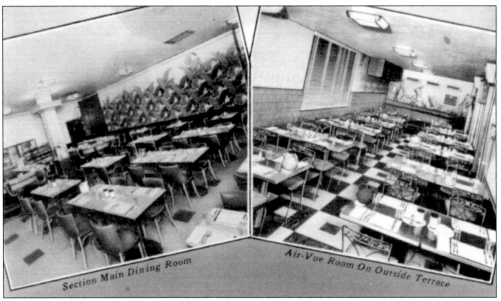

AIRPORT CUISINE. The Milleman Gilbert restaurant was enjoyed not only by airport travelers, but it was also an integral part of a Sunday afternoon outing by locals who wanted to "watch the planes" take off and land. This postcard illustrates the dining room, which was on the top level of the passenger station. One could choose between the indoor and outdoor terrace in the early airport days at Municipal Airport. Good, inexpensive food, plus the "air show" made the restaurant an ideal place to visit.

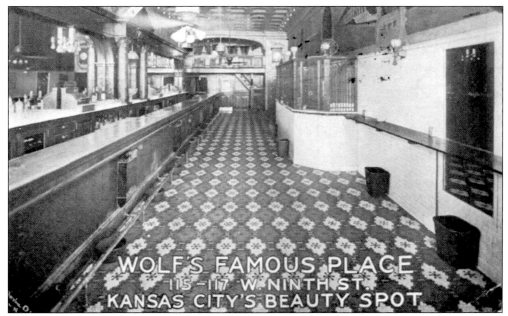

SWINGING DOORS? Wolf's Famous Restaurant was perhaps a favorite place of cattlemen after a busy day and many sales at the stockyard. Note the cages used for financial transactions, the tiled floor, bar rails, and spittoons. The decorative pressed tin ceiling was probably lowered to conserve heat. This postcard is dated 1914, and reads, "I may go to Sedalia Friday if I do I will be on that morning train and will be out . . . Ed."

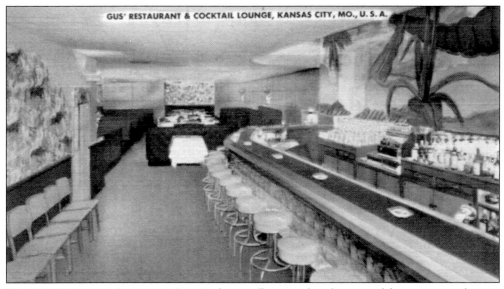

USE MY EXPENSE ACCOUNT. Gus Fitch proudly owned and managed his restaurant known as Gus' Restaurant and Cocktail Lounge for over thirty years. The restaurant was renowned for having the finest steaks and fancy seafood, including lobster. A successful restaurateur, Fitch even provided seating for guests who might not want to sit at the bar while waiting for their table. One can only imagine the many clients wined and dined at this establishment as they transacted business deals.

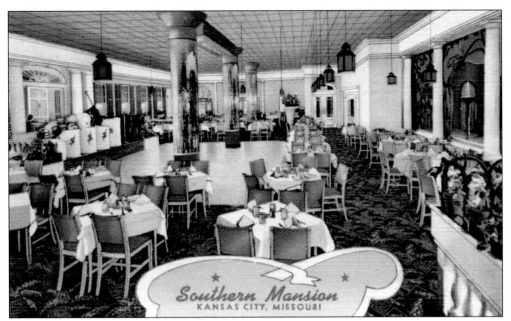

THE ULTIMATE DINING EXPERIENCE. Located at 1425 Baltimore, the Southern Mansion provided luxury dining according to Thomas Atkin, who accompanied his parents to this restaurant in the late 1940s. Outside the mansion, a marquee advertised what name-band would be performing, and upon inspection of the post card a large marble dance floor can be seen in front of the bandstand, complete with microphone for a vocalist.

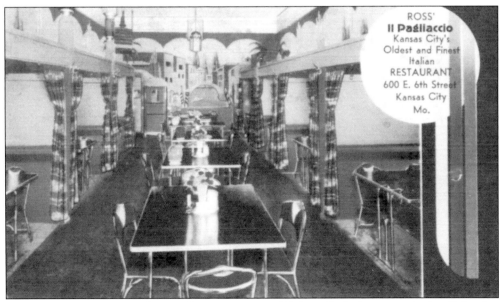

ITALIAN DELICACIES. Ross's Il Pagliaccio eatery at 600 East Sixth Street was in the Columbus Park area of early Kansas City. The large tables accommodated family groups and yet gave privacy in booths with curtains. Later Italian style restaurants in the downtown area were Jennie's and Italian Gardens. Pasta and other spicy and flavorful foods were a welcome treat compared to the usual meat and potatoes menus of Midwesterners.

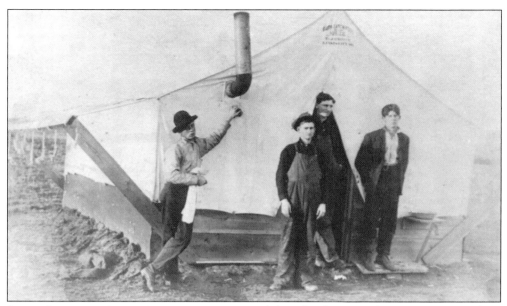

SOME CALLED A TENT A HOME. Many men and their families arrived in Kansas City seeking medical help for tuberculosis and other maladies, but found no beds available in the hospitals. They soon overflowed onto the hospital grounds, creating makeshift treatment areas using tents. Other families found work in the stockyards, but no permanent accommodations. They took shelter in tents, or "shanties," in the West Bottoms. Work was plentiful for skilled men in the stockyards, where it's said the workers were so adept, they could slaughter cattle and have it ready for transport in minutes.

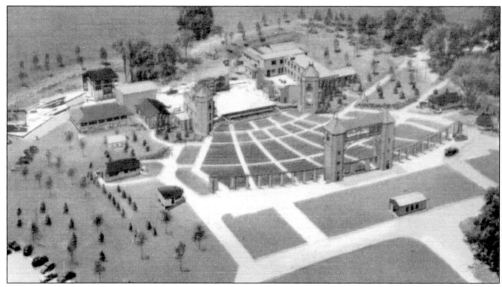

STAR LIGHT, STAR BRIGHT. After years of complex financial planning, site changes, and bond issues, the Starlight blossomed to entertain generations of families on soft summer nights at Swope Park. Run by members who subscribed to the Starlight Theatre Association, the theatre was complete enough to host a historical revue, "Thrills of a Century," from June 4 to July 10, 1950. The complex was completed when the season opened in June 1951, with "Desert Song."

VAUDEVILLE VENUE. An outgrowth of the Abraham Judah's "Dime Museum," featuring sideshow curiosities of dwarfs, giants, and Siamese Twins, or the risqué song and dance of earlier variety shows, was the Orpheum Theatre. Built in 1892, by H.D. Clark, and managed by Martin Lehman, it was changed to a family oriented format called vaudeville. Opening night performers included a magician, band, comedy sketch, and singers. After much success, the Orpheum was relocated in 1914 near Twelfth Street.

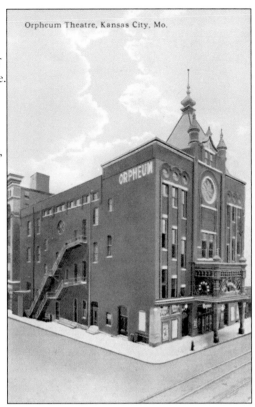

Orpheum Theatre, Kansas City, Mo.

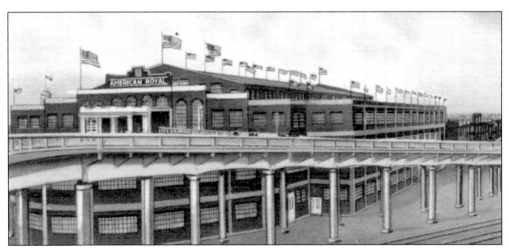

SOCIETY AT THE ROYAL. Only two events ever cancelled the Royal: hoof and mouth quarantine in 1914 and the war years of 1942 to 1945. The Saddle and Sirloin Club and the Belles of the American Royal were added in 1941. Milestones in social conscience were the addition of women judges in 1941 and the first African-American exhibitor in 1931, Tom Bass, an accomplished horse trainer. Tom's skill with horses became world renowned and he traveled to London to appear before Queen Victoria. His brother, Jessie Bass, was also proficient with horses and managed General Palmer's stables in Colorado. Celebrations with parades and social events still mark the American Royal today.

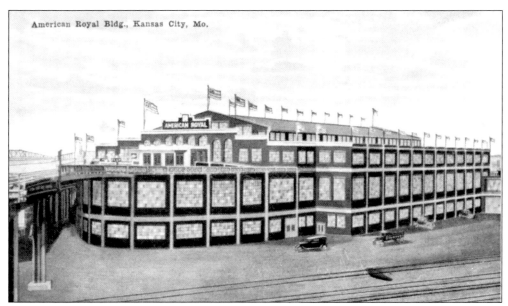

American Royal Bldg., Kansas City, Mo.

PROTEIN DIET. Evidently, the American Royal was outgrowth of "Fat Stock Shows" that were held by the Stockyard Association. The first home was under a tent in 1899 and organized by Hereford breeders. In 1901, it was renamed after the English Royal because of its goals of purebred breeding. Community participation has been the key to the Royal's success. Indeed our postcard writer in 1924 exclaims she is, "having a splendid time!"

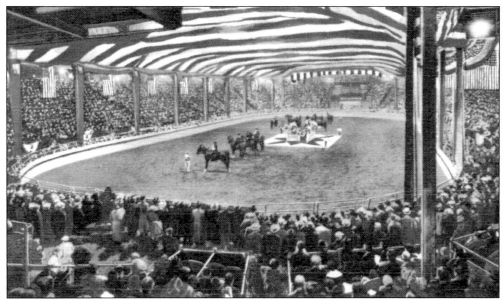

UPSTAGING THE LONGHORN. Many businessmen had country estates with cattle herds imported from Europe. William Rockhill Nelson entered his shorthorn cattle in the show of 1900. When horses became used for pleasure, instead of transportation and agriculture, they became an important feature of the American Live Stock show. Fairness and integrity in judging was a source of pride at the show. This postcard shows judges awarding ribbons to exhibitors, it's dated 1938 and reads, "Greeting to you both, Blanche."

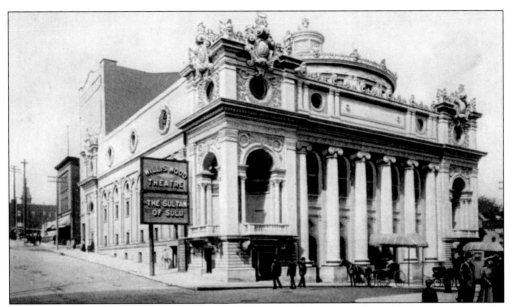

CURTAIN CALL. Willis Wood watched construction of his theatre from his hotel room at the Baltimore. The St. Joseph merchant persuaded Louis Curtiss to design an ornate theatre to replace the Coates Theatre that burned to the ground in January 1901. Opening night, August 24, 1902, the 1,527-seat theatre sold box seats for $7. The first person to pass through the tunnel connecting the theatre to the Baltimore hotel paid $35. Note the play on the marquee, "The Sultan of Sulu." It later became a burlesque house and after that showed silent movies, but the theatre burned to the ground in 1917.

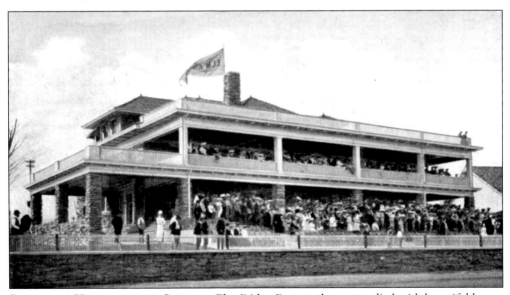

PLENTY OF HORSES IN THE STABLES. Elm Ridge Racetrack was supplied with beautiful horses that were plentiful in the region. The track was one of the many attractions advertised in the Times newspaper for the 1908 Independence Day celebrations. As with other local racetracks, pari-mutuel betting was illegal in Missouri. Therefore, tickets were purchased at a window marked "donations" and winnings were redeemed at the window marked "refunds."

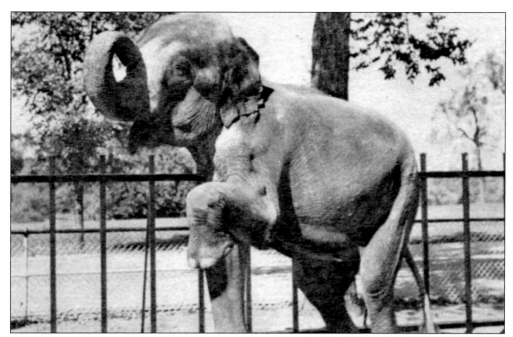

NOT YOUR AVERAGE ELEPHANT. Ararat the Indian elephant strikes a pose at the Kansas City Zoo. She was 34 years old at the time of this photograph and was said to have eaten a bale of hay a day. For treats, she preferred popcorn rather than peanuts. The Kansas City Zoo opened on December 13, 1909, amid much celebration. It was supported financially by a group of people known as The Friends of the Zoo, as well as being sponsored by private individuals and businesses in the city.

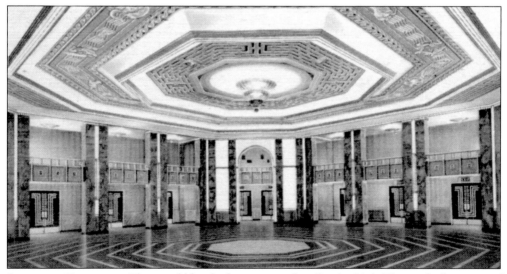

STUNNING ELEGANCE. That would be the best way to describe the Little Theatre, built as part of the Municipal Auditorium in the mid-1930s. While the 600-seat Music Hall just across the Grand Foyer accommodated stars such as Leslie Howard and Fanny Brice, this 5,000 square foot venue was designed as a ballroom or banquet room. Its marble floors, art deco lights, and 19-foot high ornate ceilings designed in an octagon shape made many memorable events for attendees.

EXTRA CRISPY? This could have been asked when visiting the Green Parrot Inn at Fifty-second and State Line. Operating from 1929 to 1955, its family style chicken dinners, served in a pleasant country-like setting, was a favorite popularized by a Mrs. J.B. Dowd. You might join some 300 diners who would forgo their favorite liquor just to savor her biscuits and mashed potatoes with gravy. Her sons and husband later joined her successful business venture.

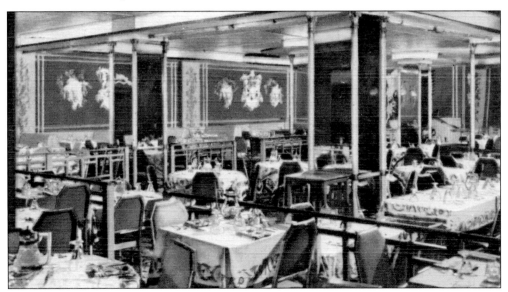

MAY I HAVE THIS DANCE PLEASE? These were words you may have heard during lunch or dinner at the Muehlebach Hotel's famous and elegant grill. It replaced the Plantation Grill, a tea room furnished with ferns and wicker before it was converted to this 400-seat dining room and dance floor. As entertainment, nationally known orchestras such as Ted Lewis, Guy Lombardo, or Buddy Rogers were joined by vocalists Julius LaRosa or Sophie Tucker. This postcard is dated March 5, 1947 and reads, "Iowa hasn't anything on Missouri when it comes to snow. Drove in the worst storm I've been in this year . . . Love M.J."

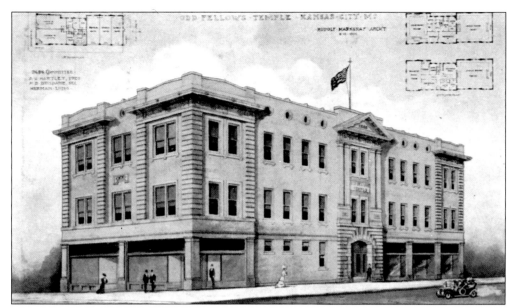

A Place for Odd Fellows to Meet. In 1857, the first Odd Fellows meeting lodge was established in Kansas City. The Kansas City Journal-Post reported, "The new temple, which is one of the finest in this section of the country, has been under construction since 1905. Realizing the financial difficulties … shares were sold at $5 each. No one was permitted to buy over 1,000 shares and every shareholder had to be an Odd Fellow."

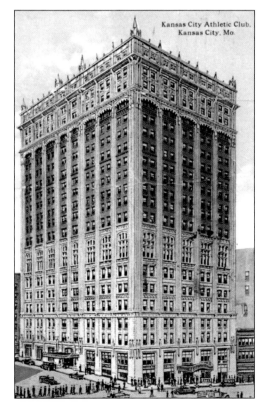

Quite a Dandy. The Kansas City Athletic Club seen on this postcard is palatial in appearance. The postcard is dated 1928, and was sent to Leadville, Colorado. It reads, "Dear Geo, Back at the old game with one of these small concerns here. Footing 106 Mil. Am sure glad to get back to the life of ease, you know. This is one of the newest Bldgs. sure is a dandy. Drop me a line when not too busy. Regards to all."

Five

SIGNS OF THE TIMES
TRANSPORT AND STREET SCENES

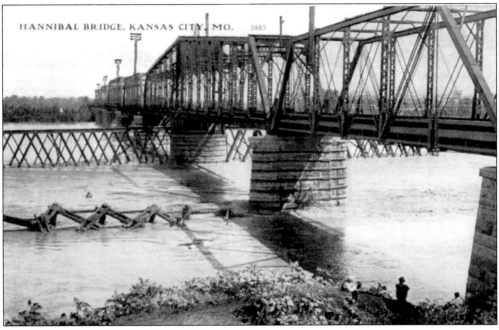

HANNIBAL BRIDGE, KANSAS CITY, MO. 5883

CELEBRATION EXTRAORDINAIRE. On July 3, 1869, the first railroad bridge over the Missouri River was opened. It was called the Hannibal Bridge and the celebrations were beyond belief, because the Hannibal and Saint Joseph Line could now ship cattle from Texas to Kansas and Missouri, as well as speed transport of goods for commerce. Morning festivities included a parade, and the Hannibal engine, covered with bunting and flowers, gingerly entered the bridge from the north, pulling 10 cars and stopping at the southern edge. Crowds streamed down the hills and bluffs and followed the parade across the bridge. In the crowd was George Pullman, who could see two of his new sleeping cars, called Pullmans, and the "newest wonder," a dining car. Kansas City celebrated with barbeques and parties long into the night. Rightly so, for the future of Kansas City was assured its place in history with the crossing of the Missouri, via the Hannibal Bridge.

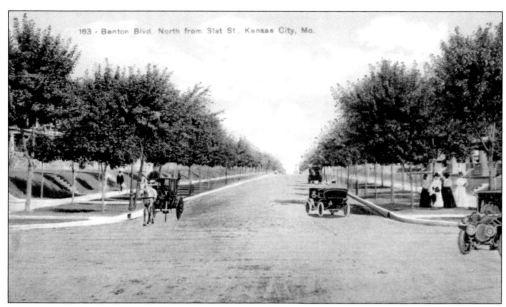

ADDRESS OF SUCCESS. Early events in the life of Thomas Hart Benton dictated that he make a new life for himself in Missouri, where he was a dedicated champion and spokesman. Young Benton was drawn to the raw frontier state of Tennessee from North Carolina, and moved to a 40,000-acre tract near Nashville. Benton was appointed by Andrew Jackson to be his aid, and became very valuable to the future president. During a bitter quarrel between Jackson and the Benton brothers, Jackson was shot and Benton was pitched downstairs. Hence, he made a prudent retreat to Missouri. This postcard is dated 1908.

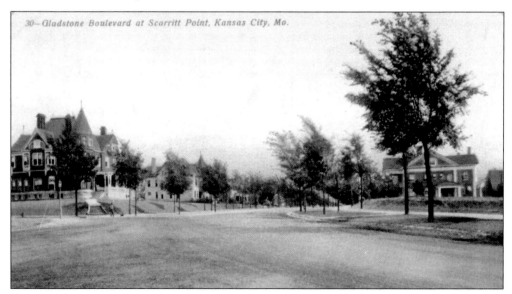

MISSING PACKAGES. This postcard shows a scene at Gladstone Boulevard at Scarritt Point. It is dated June 20, 1909, and reads, "Dearest Mother, Did Uncle Seph get the packages yet? They were addressed in error. I hope you are feeling well. We are excited to come to Skidmore July 2, am anxious to see you. Bess will be along I think. Tell Uncle Seph he cheated us out of the chimes. We will cheat him when he comes to see us and expects cherry pie. With Love."

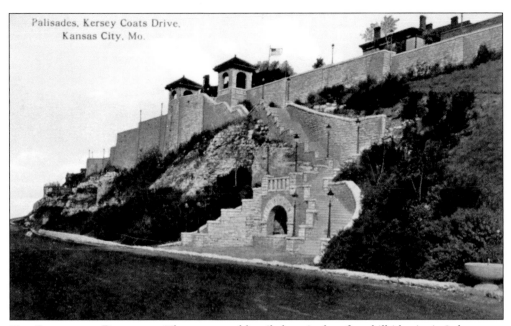

THE IMPRESSIVE PALISADES. The scene could easily be mistaken for a hillside city in Italy, except for Old Glory fluttering atop the building. The view from this point would be of the activities of the Bottoms and the Twelfth Street Viaduct. This postcard was sent to Westphalia, Kansas. It is dated July 23, 1912, and reads, "Well John don't forget old K.C. I am looking forward for you and J.V. to come up this Winter and we will have a fine time."

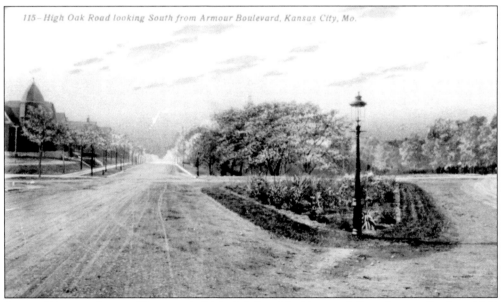

115 – High Oak Road looking South from Armour Boulevard, Kansas City, Mo.

SISTER HELPING SISTER. The scene is High Oak Road looking south from Armour Boulevard. J.C. Nichols later developed a sub-division called Armour Hills, which was located south of Sixty-fifth Street. Bungalows sold for $8,500 and two-story homes for approximately $9,500. This postcard is dated August 3, 1914, and reads, "Dear sister, Please send about a quart of varnish. I can't get it here, let me know what the difference is and I'll send it right away. All well. Grace."

71

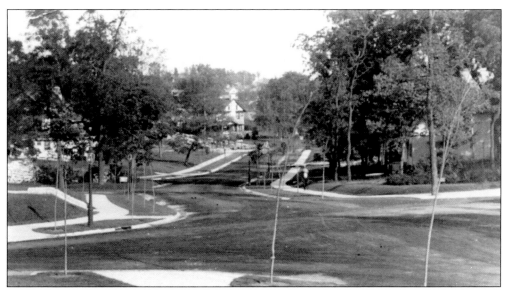

ARTISTIC HOMES BUILT FROM ORIGINAL PLANS. This postcard is dated July 1, 1910, and there is no message, only a brief description, "Manheim Road links Harrison Boulevard at Thirty-eighth Street, with The Paseo at Fortieth Street. Admirably fitting the topography, this road intersects a district of artistic homes built from original plans, thus giving individuality for each home in Squier Manor." Note the fledgling trees in this young neighborhood.

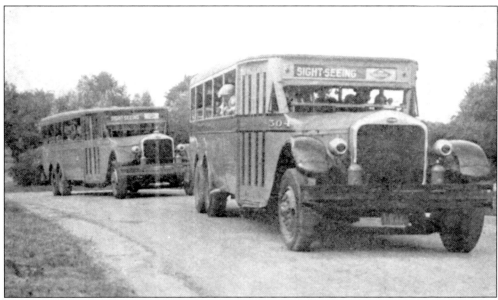

THE RIGHT COMBINATION. During the 1920s, a beautiful system of parks with fountains and wide boulevards was taking shape on the eastern side of the city. During this time it is estimated that the population was almost 325,000, there were 19 Piggly Wiggly grocery stores, and 26 beauty parlors. The invention of the large combustible engine used by the Gray Line Bus Tour Company offered sightseeing adventures around the town for a modest price. The tour left from the Baltimore Hotel at Eleventh and Baltimore Street. The notation on the card reads, "Phone: Grand 0050 to reserve your seat on the next tour."

NOT SAFE TO WALK DOWN 12TH STREET. Thomas Atkin shared this quote from his grandmother as she described the dangers a woman walking along Twelfth Street faced, "At any moment, the doors of a bar would fly open and the fighting would spill out onto the street with no consideration of those who might be innocently walking nearby." This postcard is dated 1925 and indicates pool halls and burlesque houses in the area. Message reads, "Dear Dad, Am arrived okay but have not got a job yet. Am going over to Cowdin this PM. With Love, Jack. Love to Mother."

GREEK GODDESS PALLAS ATHENA. The ornate parades were named for the Greek Goddess Pallas Athena, goddess of science, wisdom, and arts. The Flambeau Club was a public-spirited organization eager to advance the interests of Kansas Citians. They held many events where men impersonated women because they believed women were too delicate to participate. Later, liberated women assumed their roles as beauties at all events. This postcard, dated 1912, reads, "Dear Mary: I hope you will parden me for being so slow in sending you a card. I have been real buisy [sic] house cleaning."

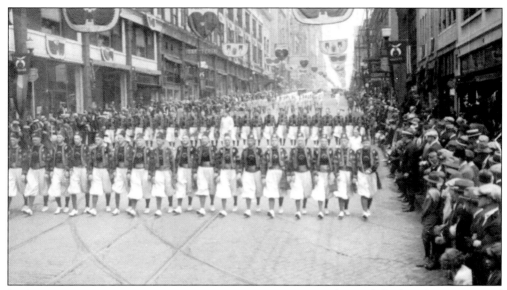

IT SEEMS LIKE ALL THE MEN HERE WORE RED FEZZES! This card displays the precision of the marchers, banners, and crowded parade route. Note the formal dress of the spectators as they stood four deep to watch the procession. A woman describes the scene in Kansas City at the last parade of the Priests of Pallas. This postcard is dated 1924, and reads, "This was a most wonderful parade. It seems like all the men here wore red fezzes. Kansas City is a very beautiful place. The good part of it looks like a huge park."

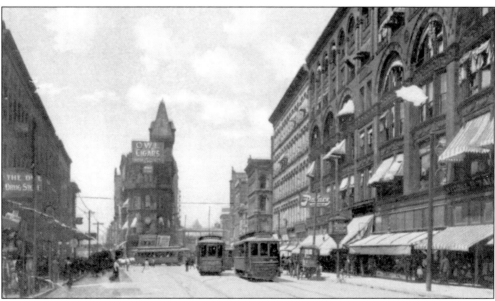

MORE EXCITING THAN A ROLLER COASTER. This was the description given by Thomas Atkin's grandmother as she rode the cable car to transfer to the streetcars pictured in this postcard. It seems that the steel cables that controlled the speed of the cable car as it came into the station sometimes stretched, and at the last minute of the ride it was sometimes questionable if it was going to stop at all. This postcard is dated 1922 and reads, "Dear Aunt Annie: I've meant to write before, but have been expecting to come . . ."

SIBLING RIVALRY. The scene on the postcard shows The Paseo. Note the beautiful four-story apartments overlooking the vine-covered center stonewall. Strollers living in these apartments could have visited the Sunken Gardens nearby. However, the quiet street scene would change drastically over the next few years, prompting the Safety Council to consider a one-way system at The Paseo and Linwood Boulevard. Evidently even in 1911, families had their problems. This postcard, dated 1911, reads, "Hello Sis How is everybody? Why didn't you let me know you were coming through K.C. last Sunday? Am well and making Lard. Lovingly, H.E.B."

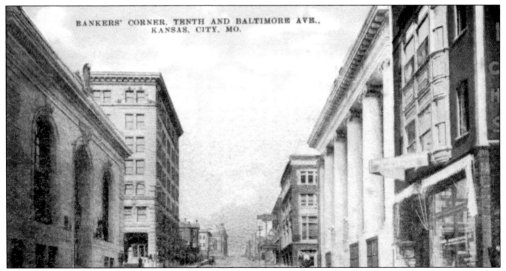

INVESTMENT CONSULTANTS. The area was known as Banker's Corner, located at Tenth and Baltimore. There was quite a change from 1906, when the First National Bank opened its doors. Riding the wave of prosperity were these newer banks such as the Central National, National Bank of the Republic, New England Bank, Pioneer Trust Company, United States and Mexican Trust Company, and the Commerce Trust Company. This postcard is dated 1909 and has no message. It shows a busy commercial area comprising six banks.

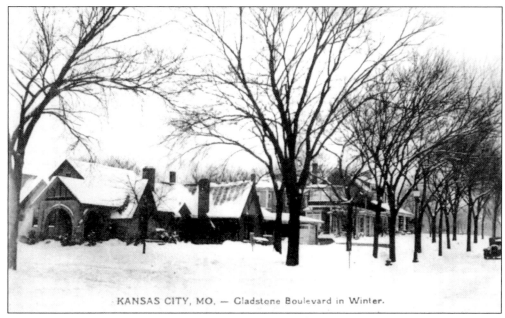

KANSAS CITY, MO. — Gladstone Boulevard in Winter.

A WINTER SCENE ON GLADSTONE BLVD. Snow is nothing new to Kansas City and appears on this postcard, dated 1930. The city continued to grow during the 1930s with a new Jackson County Courthouse, the Municipal Auditorium, and a project to control the Blue River. The message on this postcard reads, "We got this card for you. Doyle and Janet are still in Trenton. Doyle is working with Wayne and George, don't know what Jarret is doing. Everyone else is fine. Love Maureen."

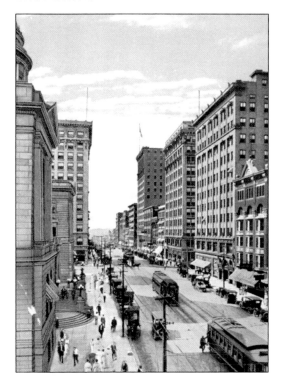

THE FIRST ROAD TO WESTPORT. Records indicate that Grand Avenue was the first road from the Missouri River to Westport. The scene on this postcard looks south from Eighth Street and shows some principal businesses: the post office and the Grand Avenue Temple. Businesses flourished, especially beauty parlors. In 1923, there were only 26 beauty parlors in Kansas City, but three years later, there were 223. Evidently we owe the width of Grand Avenue to Mayor Milton McGee, who wanted it built wide enough so he could turn his horse and buggy around in one maneuver.

76

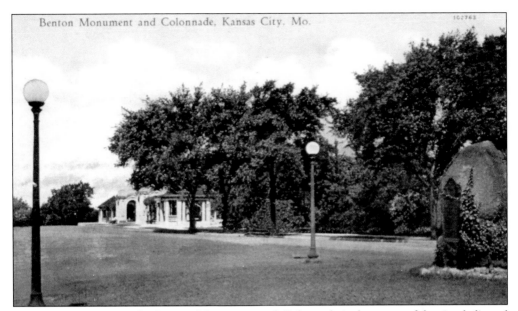

Benton Monument and Colonnade, Kansas City, Mo.

A STATELY TRIBUTE. The Benton Monument and Colonnade is the name of the site dedicated to the memory of Thomas Hart Benton (1782–1858). He was known as a lawyer, editor, scholar, statesman, congressman, and U.S. Senator for Missouri for over 30 years. He also championed the pony express, the telegraph, interior highways, opening of the Oregon and Santa Fe trails, and transcontinental railroads. These infrastructures assured Kansas City's prosperity long after Benton's lifetime.

PLACES TO GO—PEOPLE TO MEET. A busy scene on Main Street looking north as people go about their business, gathering on the curbside and street corners to visit. There are trams in the street and cars parked at the side curbs. This postcard is dated 1931 and reads, "Had a nice time in Kansas City. We don't have to leave until 2:00 P.M. Stayed with some nice people who drive us all over town. Elver."

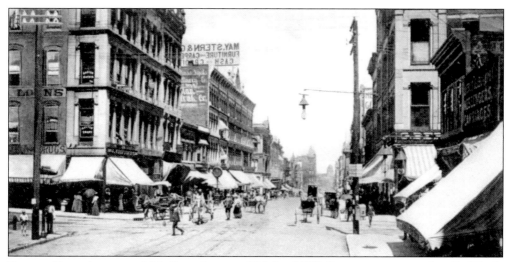

BATTLE ROW. An area on Main Street between Third and Fifth Streets was commonly called Battle Row because of the numerous fights that would erupt in the saloons and spill into the street. It is reported that Wild Bill Hickok liked to gamble in Marble Hall on Main Street with his lawman friend, Wyatt Earp. This early, undated postcard, shows horse-drawn carriages in the street as women wear long dresses with bustles and large hats. Some men wear cowboy hats.

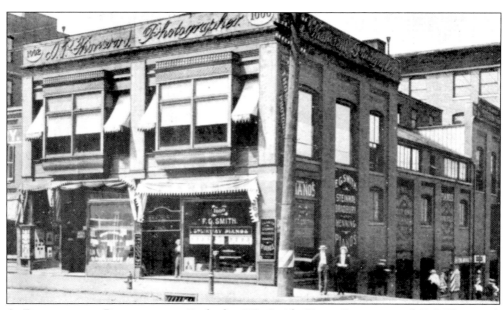

A PIANO OR A PHOTOGRAPH. Both the F.G. Smith Piano Company and D.P. Thomson's photographic studio were located on the corner of Tenth and Walnut. Men pose for the photograph in straw boater hats, and one appears to be peeking out of the doorway of the piano shop. D.P. Thomson became a very successful photographer in Kansas City, taking more than 175,000 photographs. He was a member of the original Priests of Pallas board of directors.

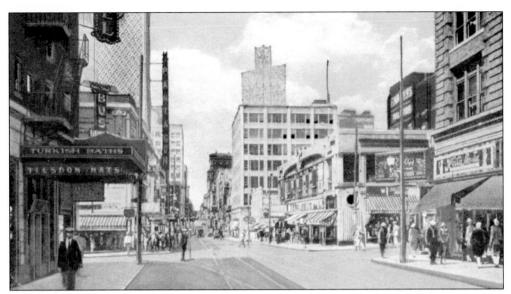

An Influential Family. The postcard's point of view is Twelfth Street looking west from McGee. Early records indicate that the McGee family arrived in Kansas City in approximately 1786. They became quite wealthy, owning land and businesses in and around the area. Their family was the first to have a brick building in the city. This postcard is undated, but likely around the 1920s to 1930s, as women on the street are wearing flapper style hats and their hemlines are seen just below the knee.

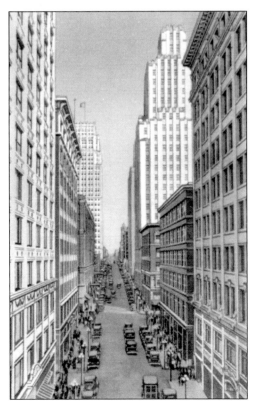

What's In a Name? The origin of the name Petticoat Lane is vague. Some people suggest it was because of the abundance of women's shops in the area, others think the name stuck after a poem appeared in the Kansas City Star in the late 1890s. But perhaps the origin came from its namesake in the heart of London's East End. Petticoat Lane is located close to Aldgate, an ancient part of London. Women's shops line the lane, which also has an open marketplace. In London, Petticoat Lane is part of a specific area commonly called the "rag" district.

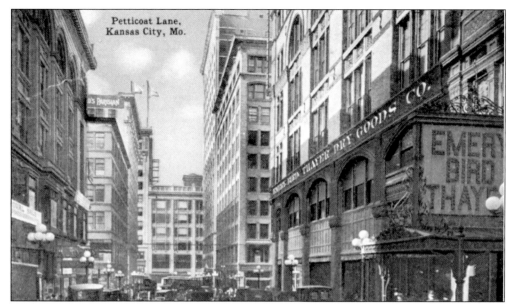

A Cherished Memory. Ann Arensmeier recalls, "When I was ten years old, my family came for a day trip from Kingston, Missouri in late summer to buy my school clothes. My father and brother headed for Woolf Brothers but Mother and I headed to Emery, Bird, and Thayer. Closing my eyes, I can still see the receipt boxes humming along the ceiling, veering sharply at the intersections, taking cash to the central cashier and reversing directions. I can even remember the tempting aromas wafting from the Mezzanine where my father would join us for lunch."

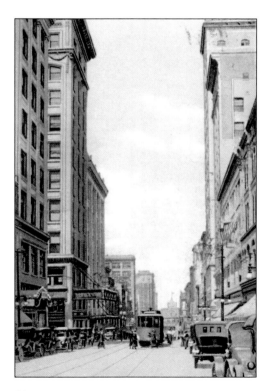

Feeling Blue in Kansas City. This postcard looking north on Main Street was sent to a lady in Whittier, California, August 1921, and reads, "Dear Luella, Well we've arrived in Kansas City 5:30. Our train doesn't leave till 10:45. Have been for a few hours drive thro. the city. Kansas City is sure busy. Am still feeling blue. But can't be helped now. Well Luella I'll write again when we get home. So be good. With Love, M &H."

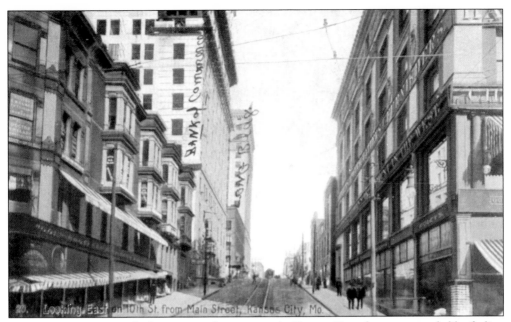

KANSAS CITY HILLS. The large areas of open space in Kansas City often gave a park-like feeling that surprised many visitors. The scene is looking east from Tenth and Main, and mentions the hilly area where the card sender lives. This postcard is dated 1908 and reads, "This view gives a fair idea of Kansas City hills . . . We live . . . six blocks on this hill and its beautiful." The postcard was sent to Miss Annie Young in Palmer, Massachusetts.

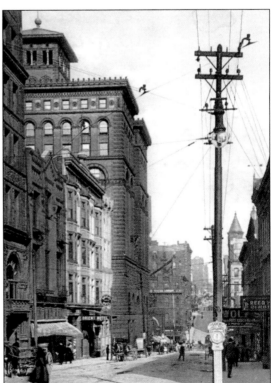

WAITING FOR THE TRAIN? This view is from Ninth Street, east from Wyandotte. There are only horse-drawn carriages in the street and women can be seen wearing full-length dark dresses and large hats. The Orient Hotel can be seen in the center of the block. This postcard is dated February 3, 1910, and was sent from St. Louis on a Thursday morning. The message reads, "All OK so far. Have to wait here till 9 o'clock. Love to all. Ina." Card sent to Perry, Oklahoma.

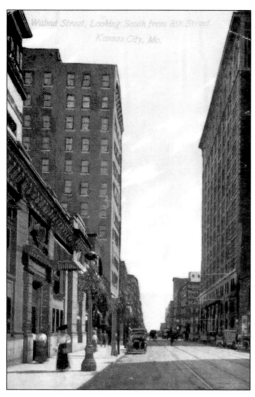

LIVING IMAGE. The scene looks south from Eighth Street. This postcard, dated 1911, reads, "Dear Lulu, How is everybody with you why don't you write. Lillis baby is the living image of Ina when she was 6 months old pretty blue eyes bald headed and fair skin, send me a card once in a while. Would love to see . . .Your Sister Lela." Sent to Mr. and Mrs. Kelso, Washington.

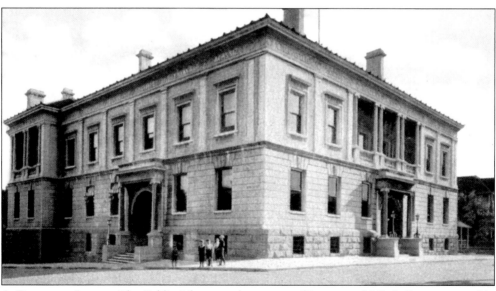

A PLACE TO LEARN. The Public Library at the corner of Locust and Ninth Streets opened in September 1897. It was an impressive building at the time, housing 30,000 volumes, as well as reading, reference, and children's rooms. Kansas City continued to grow steadily during the early 1900s. In 1909, more land was annexed by the city, bringing the total area to more than 60 square miles. This postcard is dated 1909, and reads, "Dear Alice, Impossible to come tomorrow but will let you know when we can come . . Lovingly, Dorothy."

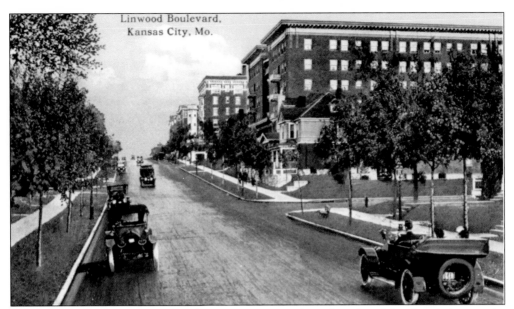

FIGHTING HIS WAY THROUGH. The scene is Linwood Boulevard and the description on the back reads, "One of the principal boulevards in Kansas City's 65-mile beautiful boulevard system." Postcards often reflect the writer's happiness, worries, and concerns. This postcard, possibly written by a young man, is dated May 10, 1917, and reads, "Dear Father and Mother, I am going to try and write to you this afternoon and let you know that I am a fighting my way through - tell Harvey to take good care of his self [sic] and he will soon get well."

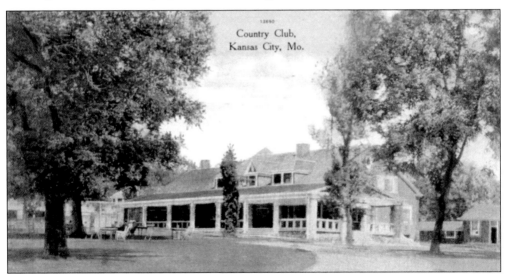

CERTAINLY AN UPGRADE. After modest beginnings in a cow pasture near Westport, the Kansas City Country Club built its clubhouse near Fifty-second and Broadway in 1896. In 1925, 275 members enjoyed the club until the heirs of Seth Ward cancelled their lease. They moved to Kansas at Sixty-second and Indian Lane. Mrs. Jacob Loose purchased a portion of the golf course for Loose Park in memory of her husband. This postcard is dated 1909, and reads, "Do tell me how you are both getting on at school - such a big - big girl to go . . . Love and kisses to you both. From Auntie B."

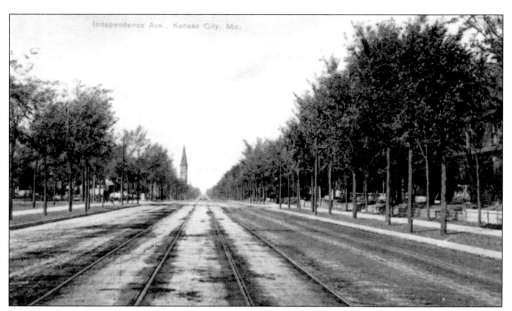

THE GATEWAY OF KANSAS. This is an early scene on Independence Boulevard. There was once a time when residents of Kansas City built beautiful homes on the boulevard. Harper's Weekly ran an article on February 5, 1888, stating that Kansas City was the place to live. "Society is yet in its formative state. It is naturally of a cosmopolitan character...some of the oldest houses in the city are on the West Bluff (Quality Hill) overlooking the West Bottoms."

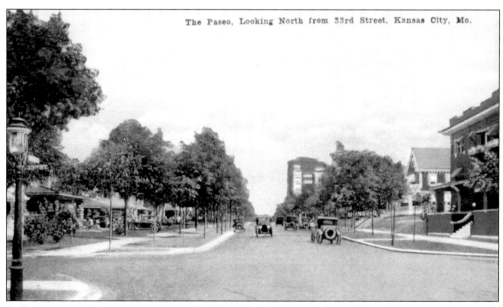

A PRESTIGIOUS NEIGHBORHOOD. The Paseo, looking north from Thirty-third Street, shows the mid-twenties scene with its mansions on the west and brick apartments on the right. The inspiration for The Paseo came from August Meyer, who wanted a boulevard similar to The Paseo in Mexico City. There were probably more postcards depicting various scenes of The Paseo than any other street in Kansas City. Note the use of limestone building materials in the homes, and the cars that were parked on the drives. No streetcar line here—suburbia has arrived!

A Postcard Collector. It appears a conductor in a white hat waits at the junction of East Twelfth as he looks down the street. A banner strung across the street from the rooftops of buildings indicates this as the 300 Block in Kansas City. This postcard is dated 1912, and appears to be sent by a fellow postcard collector because it reads, "Dear P.C. Friend, Thanks for card rec'd. What kind of cards do you prefer? Sincerely. Edith Walker." The postcard was sent to an individual in Illinois.

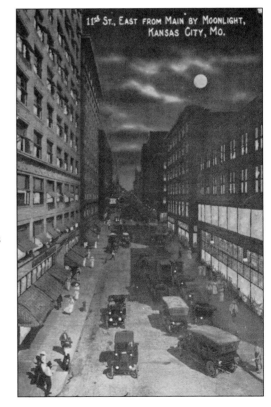

Main by Moonlight. This postcard shows an early scene at Eleventh and Main as women wear long, white dresses and large, fluffy hats, perhaps for an enjoyable evening on the town. In contrast, the postcard sender mentions sickness in the family. It is dated 1913, and reads, "Dear Cousin John . . . she will be with me all Winter . . . she was hear [sic] just three days when stricken with heemorrage [sic] of the brain . . . I am mature and a busy girlie now . . . Ida."

BEST PASSENGER STATION. The term "Passenger Station" was used instead of the Kansas City Municipal Airport that opened on December 8, 1929. During its construction, the Pendergast political machine demanded both labor concessions and purchase of cement on its terms. The airport was just five minutes from downtown by car, making this a convenient business connection. This postcard is dated 1934, was sent to Bill Imler of Kirkwood, Missouri, and reads, "Bill & Dad Got here 4:30 Dot & Blanch were at the station to meet me Every one are [sic] fine take care of that cold . . . MOM."

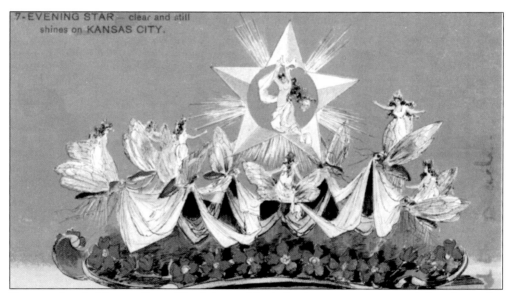

KANSAS CITY'S MARDI GRAS. The Priests of the Pallas businessmen patterned their floats after those used in the New Orleans Mardi Gras celebration. The parades and other celebrations were held from 1887 to 1924. Early parades featured elaborate floats that were built on Studebaker wagons and drawn by mules. Later, floats were constructed on streetcar flats and routed through the streetcar line routes. Dignitaries watched from balconies of elegant hotels. Festivities included social events where invited guests received many gifts. Among collectible items given were clocks, dishes, and postcards depicting the theme of the year.

Six

A City of Parks, Fountains and Bridges

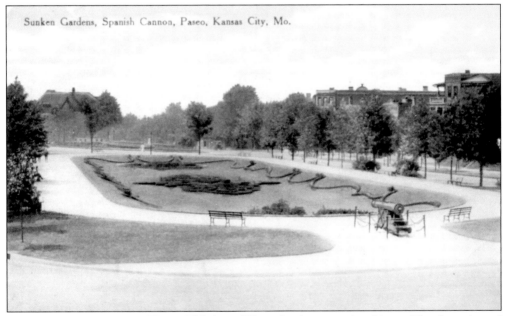

Sunken Gardens, Spanish Cannon, Paseo, Kansas City, Mo.

REMEMBER THE FALLEN HERO. This beautiful garden has a somber history. The fountain and sunken gardens were dedicated on May 30, 1922, to the memory of William Fitzsimons, M.D., a Kansas City native and graduate of the University of Kansas medical school. He was the first American officer killed in World War I. Five thousand people watched a parade in honor of the fallen hero with marching bands, Legion posts and even a group of fellow physicians. The Spanish cannon displayed in this postcard was used during the Spanish American War. It was trained on the Sunken Gardens and represents the call to patriotism that was given at the beginning of World War I by Teddy Roosevelt, decrying the senseless death of Dr. William Fitzsimons. The postcard writer was evidently an eyewitness to the parade, or similar ones held later, and hosted others who had come from a distance. She writes to her friend, "Hello Gilmer, I got home all right and seen the parade. It was just fine. You ought to have seen it. I guess Etta and the boys got home all right. Otis Fletcher stayed all night at our house on Tuesday and went home with the rest of them. Let me know when and where you move. Corianne."

AN EXTRAORDINARY EXPLORER.
The famed explorer, James Bridger's (1804–1881) monument is located in Mt. Washington Cemetery. The postcard is undated but salutes James Bridger as a worthy hunter, trapper, fur trader, and guide. He discovered the Great Salt Lake in 1824, the South Pass in 1827, and visited the Yellowstone Lake and geysers in 1830. He later founded Ft. Bridger in 1842, and opened the Overland Route by Bridger's Pass to Great Salt Lake. He was also a guide for the U.S. exploring expeditions.

A LAND DEVELOPER AND PHILANTHROPIST. This postcard shows an early view of Swope Park Boulevard, named after its generous benefactor, Col. Thomas H. Swope. The quiet bachelor donated 1,334 acres of land in 1896 that was received with such joy that a city holiday was announced. A parade was arranged where floats, vehicles, and animals marched through the city, ending at the park. When the parade finished, speeches were given and songs were sung in appreciation of the tract of land given to the people of Kansas City. Unfortunately, in 1909, Colonel Swope died under mysterious circumstances.

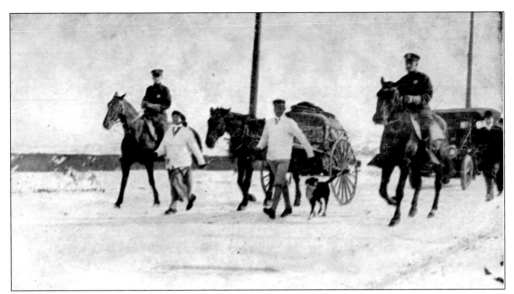

NOT EXACTLY A WALK IN THE PARK. A popular sport in the early 20th century was walking long distances. Though the reasons were varied, participants were often seen as heroes of the day. Thus, this postcard of the "Walking Woolfs" complete with their dog, Don, was enough to warrant mounted police escorts, news reporters, and a visit to City Hall. The length of their walk in the summer of 1910 was no less than 8 thousand miles!

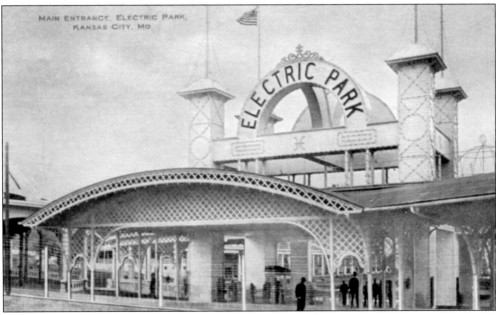

FUN ON A DIME. On Independence Day, 1908, a 10¢ admission and a 5¢ streetcar fare would liven up the holiday with fireworks, boating, bathing, and a free band concert. This was the second year the park was open. So many people attended the celebrations, Duff and Repp furniture store took out an advertisement in the Times newspaper, stating that they would be closed in order to provide two carloads of chairs for the spectators viewing the fireworks.

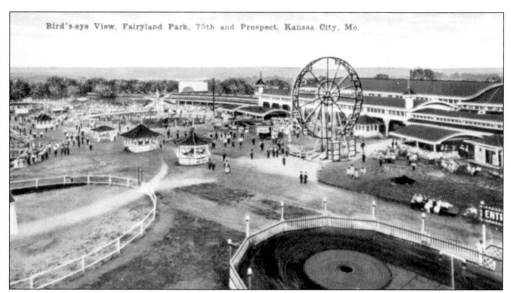

Bird's-eye View, Fairyland Park, 75th and Prospect, Kansas City, Mo.

FUN IN FAIRYLAND. In 1923, the Fairyland Amusement Park opened on 80 acres of farmland at the cost of a million dollars. Streetcars brought local and out-of-towners alike to enjoy the Ferris wheel, the Skyrocket, and the Whip, as well as water pools and concessions. Opening day was the most festive day of the year, mothers would bring packed lunches and admission was half-price to celebrate the beginning of summer vacation. The park closed its gates in 1978 when it could not rival the attractions of Worlds of Fun.

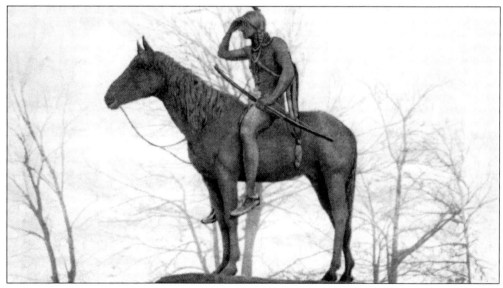

A FITTING TRIBUTE. The Boston sculptor, Cyrus E. Dallin, created the "Scout" as a memorial to local Indian tribes. It was brought to Kansas City after an exhibition in San Francisco. Its location in Penn Valley Park, overlooking the heart of downtown and the junction of the Kaw and Missouri Rivers, seems the perfect setting for this work of art. This postcard is dated 1927, and the writer seems to indicate a concern with the postmaster's curiosity. He wrote, "Bot [sic] (six) shirts@2.95, underwear@1.00 and three collars. I am presentable . . . We have Pullman to Pueblo leave at 9:45."

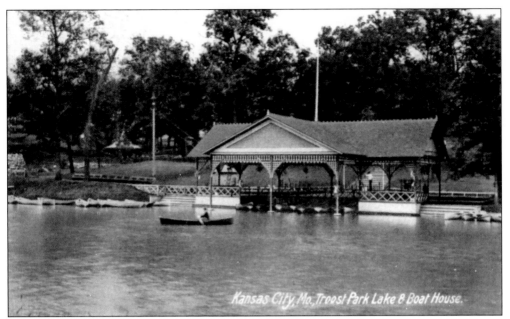

A MIDWEST OASIS. When Troost Lake Park opened in 1889, it was the first to feature many water recreation activities later used at more elaborate parks in the 1900s. A Mormon marker, dated 1831, at the south end of the two-and-a-half-acre lake pinpoints the encampment of Joseph Smith and his eleven followers from the Colesville branch. The earliest resident of this area at Twenty-fourth and Troost, Rev. James Porter of Nashville, Tennessee, arrived in 1831 with an entourage of a family, 25 to 30 slaves, and livestock. Friends share that in the 1930s, entire families slept on the lakeshore on hot summer nights.

A MORNING STROLL. In 1905, the Emery, Bird, Thayer department store published a promotional 24-page booklet on Kansas City advertising, "Kansas City's magnificent public buildings, splendid churches, fine homes, up-to-date schools, boulevards, and parks." This white wooden pergola structure was built on The Paseo shortly after 1898. The wide boulevard, with benches and gardens in the center, made it one of the most sought after places to reside at the turn of the century. The young woman in the scene wears a white dress, black stockings, and a large hat. She appears to be looking at something in the vines.

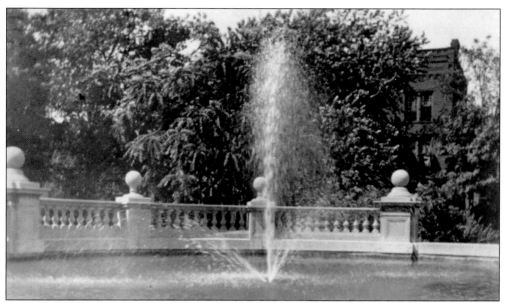

WHAT A WASTE. This 1900s vintage fountain at Ninth and The Paseo was built with a center spray sending water high in the air. It was called a waste fountain because it did not recycle water; therefore, drained directly into the sewers. In 1970, this pool reopened with circulating pumps. This lovely 1909 postcard does not match the message, "I looked for you to call me again Monday or at least before you went home and was very much disappointed at not hearing from you. Your bro, Ralph."

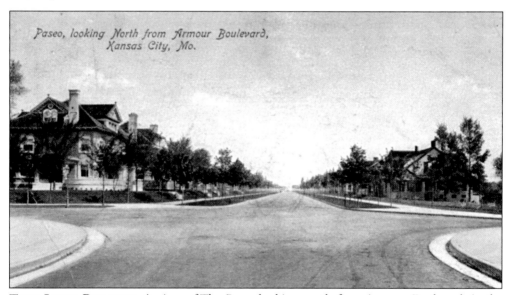

TREE LINED PARADISE. A view of The Paseo looking north from Armour Boulevard. As the population surged to the south along the garden-like setting of The Paseo, it became the perfect choice for wealthy entrepreneurs moving from Quality Hill. It was near this spot that Kirkland B. Armour, president of the Armour Meat Packing company, built a mansion that was rumored to have cost as much as Convention Hall. This postcard is dated July 17, 1909, and the writer implores her two aunts to come up from Holden, Missouri to go to a show.

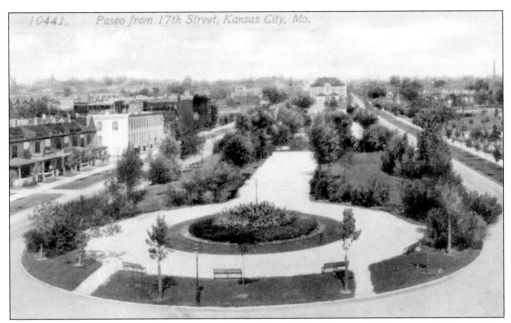

WISH YOU WERE HERE. This is an excellent shot of The Paseo and Seventeenth Street. The Paseo was a favorite place to ride in a hansom cab or for pedestrians to just promenade. This postcard is dated June 8, 1914, and reads, "Dear Mrs. Hammer, This Paseo extends through the heart of K.C. and is full of fountains and flowers and with walks and cozy seats throughout its' length. However, would enjoy it more if you were along. Allis."

Meyer Memorial Paseo, Kansas City, Mo.

HE MAY HAVE HAD A HEART OF GOLD. August Meyer left his legacy in Kansas City in many ways, including the life-size bronze monument honoring his name. The German-born Meyer made his fortune in the mines of Leadville, Colorado, as an expert in metallurgy, but his true passion was promoting "natural beauty"—no matter the public cost. His neighbor and friend, Kansas City Times owner William Rockhill Nelson, supported Meyer in his crusade for parks and boulevards, and even donated the site of his home to the city, where the Nelson-Atkins museum was built in 1933.

93

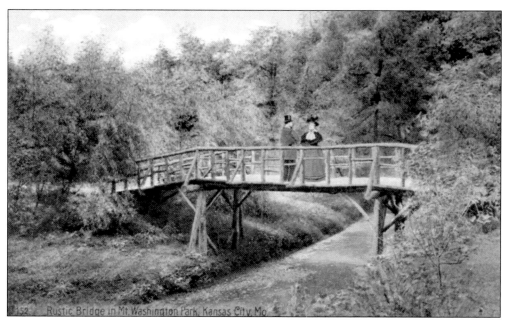

A Rustic Bridge Scene. In 1887, the Mount Washington Amusement Park boasted of having the most beautiful park in Missouri. Activities included boating, swimming, band concerts, and opera. The concept for the park came from Willard E. Winner who owned more than 2,400 acres of woodland. When the park closed in 1900, a group of Kansas City businessmen purchased approximately 400 acres for use as a cemetery.

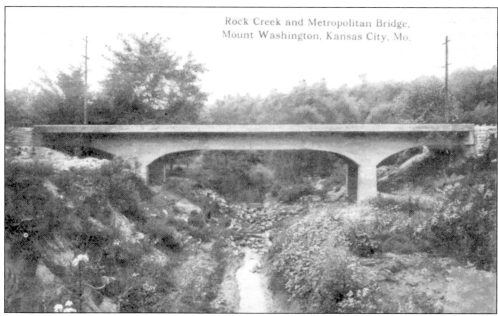

I Think of You Often. An affectionate uncle chose this view of the Metropolitan Bridge over Rock Creek as a postcard to send to his niece. This postcard is dated 1913, and reads, "Dear Niece, I am at K.C. I am feeling about the same ... I saw Vivien here today, she is a fine girl. I hope you are about well and will soon be able to go home I think of you often ...Your Uncle Lewis."

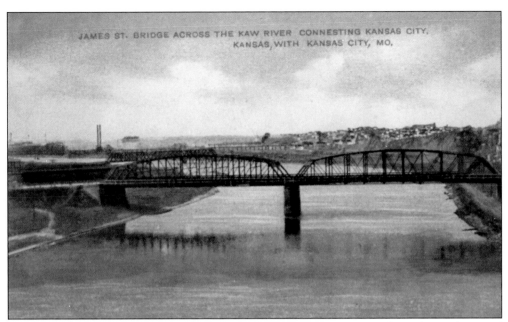

SKIRTING THE TOLL BRIDGE. Travelers who did not wish to pay a toll on the viaduct used James Street Bridge. The tolls ranged from 25¢ for automobiles, to 50¢ for an omnibus. Circus and menagerie wagons were 40¢, sheep and swine cost 5¢. People were incensed by these tolls and many refused to pay them, choosing instead to take the long route through the West Bottoms to Sixth Street; therefore, circumvented the viaduct altogether.

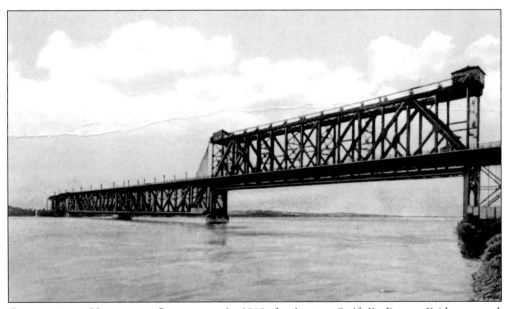

OPENING THE NORTH TO COMMERCE. In 1909, the Armour Swift Burlington Bridge opened, becoming the second bridge to span the Missouri River at Kansas City. It was the first in Kansas City to provide separate rights of way for pedestrians and traffic. An unusual lift bridge, it used a unique design that allowed automobile traffic on the top deck while at the same time permitting rail traffic on a lower deck. The lower deck also could be raised for riverboats to pass.

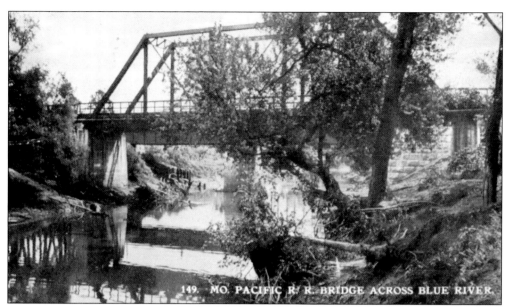

MO PACIFIC RR BRIDGE ACROSS THE BLUE RIVER. The Blue River was used for picnics, boating, and fishing for channel catfish. The more affluent Kansas Citians built small weekend cabins on its banks. Local residents and visitors also enjoyed getting away from the city for a day on the river. Unfortunately, this postcard's date is not clear, but it was sent to Chicago and reads, "Dear Carrie, We have had a very nice trip so far and will leave Denver for home tonight. Sorry we didn't get to see Milton before we left. Love to all, Hattie and Les."

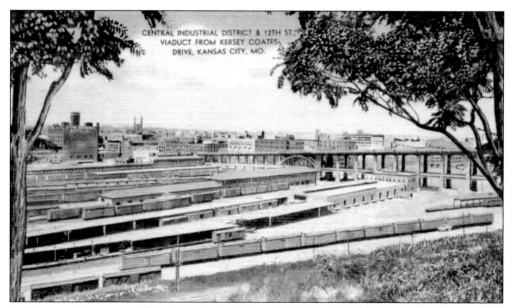

A HIVE OF INDUSTRY. This postcard shows the Central Industrial District and Twelfth Street Viaduct from Kersey Coates Drive. On March 18, 1915, a story in the Star reported, "A municipal dream of years was realized this morning. The 12th Street Viaduct was opened to traffic … A number of passengers over the viaduct today are sightseers. As the morning grew older, the patronage from this source increased and window seats were in demand."

TAKING IN THE VIEW. A horse-drawn carriage can be seen at the bottom left of this postcard, as spectators take in the view from the bridge. The postcard is dated 1912, and reads, "Dear Edna, Many thanks for the invitations but am sorry I can not be with you this evening but will visit you soon. Will see you Sunday week (June 1st) … Too bad May is never coming back. I know she will be missed by the crowd. Sincerely, Laura."

YOU'RE GOING TO GET WET! That was the warning on to the postcard sender's friend in Sedalia as he had a day of fun at Electric Park. Every hour a pedestal would rise from the center of the fountain and burst with an elaborate spray appearing to surround them. This postcard is dated August 8, 1908, and reads, "I met the rain in Nob Noster so you could get wet at the picnic!" The front of the postcard shows the lagoon that featured the most famous "Living Statuary."

CHUTE THE CHUTES. Summer time and water rides are still the best way to spend a hot and humid summer afternoon in Kansas City. In the background is the scaffolding of a roller coaster, which ended with the cars shooting down into the water. The owners of the Heim Brewing Company moved this popular park from an earlier location in the East Bottoms, to Forty-sixth and The Paseo. It burned to the ground in May of 1928, and was not rebuilt.

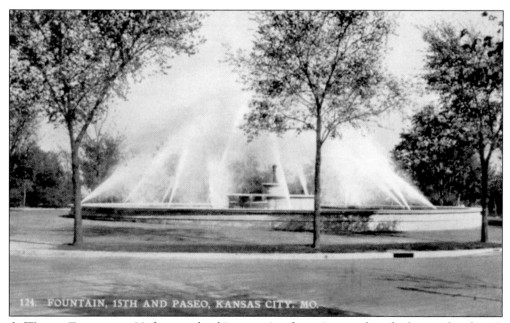

124. FOUNTAIN, 15TH AND PASEO, KANSAS CITY. MO.

A WHITE ELEPHANT. Unfortunately, this attractive fountain was described as such when it opened in 1899 at Fifteenth and The Paseo. Inspired by a fountain at Versailles, France, it was declared a "white elephant," a financial burden, and turned off in 1903. Evidently this postcard writer longed for a cool evening in the park on August 5, 1912, for she writes to her girlfriend, "Will go out to Swope Park this PM."

Seven

LIFE AND TIME IN COMMERCE

SHOPS, BANKS, AND BUSINESSES

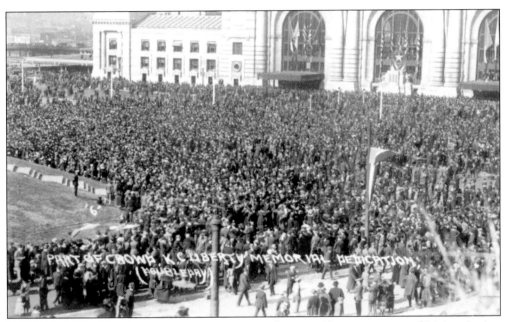

THE GRANDEST BUILDING IN KANSAS CITY. The magnificent structure of Union Station was designed by Jarvis Hunt and opened October 31, 1914. The special day was celebrated in town with a morning parade and a 21-gun salute. The station was one of the largest in the world and was the pride and joy of Kansas Citians. It was an impressive building with a waiting room that was 352 feet long. Hunt had taken into account the anticipated growth of Kansas City and therefore, provided a station that could accommodate 10,000 passengers. Understanding the climate in Kansas City, Hunt designed the station so that travelers were protected from the elements by coverings. After climbing the stairs, they were ushered into the waiting room. During the 1930s, an incident at Union Station caused Kansas City to make headlines around the world. The escaped gangster Frank Nash was being escorted out the front door and back to Leavenworth when Nash's friends tried an unsuccessful rescue of their buddy. During the melee that followed, four officers and Nash died in the parking lot.

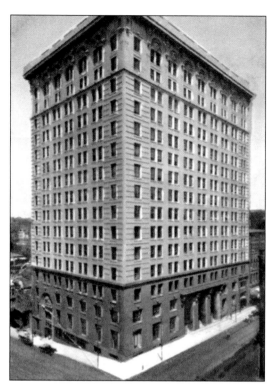

A YOUNG, WORTHY MAN. The National Bank of Commerce was located at Tenth and Walnut in the Journal Building, but unfortunately, it was destroyed by fire in 1906. At 19 years of age, Harry Truman worked at the bank from 1903 to 1905. One of his job references called Harry, "a young man worthy of all confidence, being strictly truthful, sober, and industrious." This undated postcard reads, "Dear Billy, What is the matter? Never hear from you . . . sent the . . . What is the matter?"

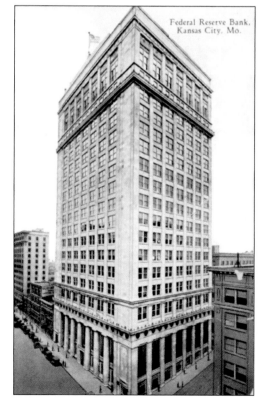

AN IMPRESSIVE NEO-CLASSICAL STYLE BUILDING. After World War I, the Federal Reserve Bank began a new building at 925 Grand Avenue. Architects used the neo-classical style considered very popular from 1919 to 1921. This postcard is dated January 21, 1940, and reads, "Dear Virginia, I've been so upset ever since I returned, never so overwhelmed with sorrow that I've not been myself. You have a charming taste & I think the pin very lovely."

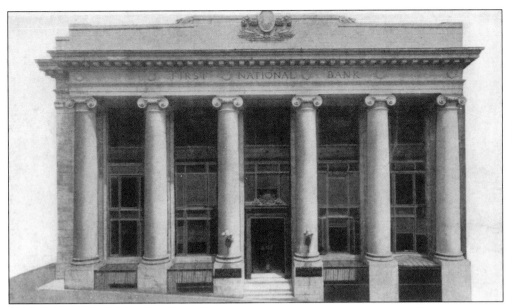

A PLACE OF BUSINESS. The First National Bank of Kansas City was one of many located at Tenth and Baltimore, an area often referred to as "Bankers' Corner." The first president of the bank was a gentleman called Taylor Abernathy, who joined the firm in 1910. He came from the influential Abernathy family that owned the Abernathy Furniture Company in Kansas City. By the year 1912, the rapidly growing city's 81 movie theatres, 71 schools, and an advance street railway system, stretching for more than 260 miles, led to a necessity for many financial institutions.

FIREPROOF BUILDING. Every decade of early Kansas City brought features that improved both the safety and appearance of the commercial buildings. This financial building at 1009–1011 Baltimore was called "fireproof" because it was made with a steel frame and reinforced concrete floors. Other amenities were high-speed elevators and a marble corridor and stairways. This postcard appears to have been written in 1918 and mentions a family reunion on Friday evening. "Do you miss us? Bridge & bridge and . . ." Greetings from . . ." The postcard contains a list of women's names and presumably their Bridge scores.

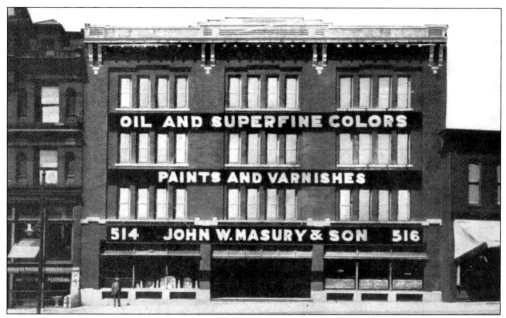

A Few Pointed Questions. A few good questions are asked of Mr. and Mrs. John Woodbury, and they aren't about paint and varnish, of which the card advertises. This postcard is dated July 7, 1912, and reads, "Dear Friends, Why don' you anser [sic] my letter we are looking every day for a word from you or do you wan [sic] us to come up there and pay our visit back which way shall it be will you come down here or shall we come there, how are the blueberries this season–good or bad please let us know with love from Fred and Rebecca."

Call Valentine 7900. The Home Rug and Curtain Cleaning Company used this advertising card to claim they had the latest equipment for taking care of your household furnishings and garments. This postcard is dated January 22, 1947, and is addressed to Mrs. John Schull, who evidently is a postcard collector, as is the writer, Margaret Chittenden. The message reads, "I like to get the advertising cards as they are the hardest to get."

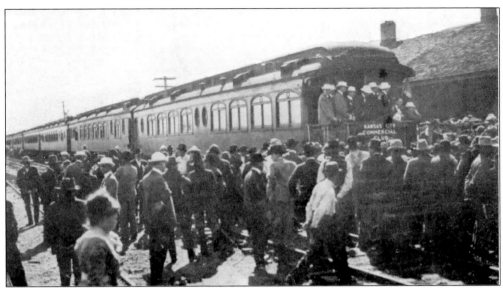

THE KANSAS CITY COMMERCIAL CLUB. The club was organized in 1887, and in 1911 boasted of a membership consisting of 850 leading businessmen with the stated objective of improving the commercial welfare of Kansas City. Their greatest triumph was the rebuilding of the convention hall in just 90 days after the original building was destroyed by fire on April 4, 1900. Their work was accomplished through 12 standing committees. They met every Tuesday, October through May. This postcard, dated 1911, shows the dapper attire of these influential businessmen. It reads, "Just pulling into El Reno. Kiss Aunt Sue for me. We are having a good time. Mutz."

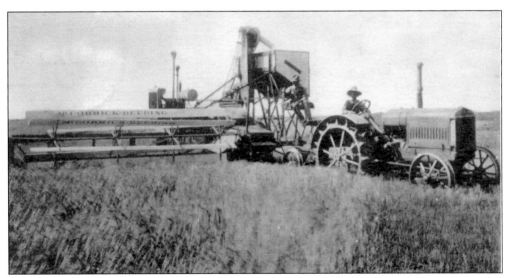

A COMBINE IN ACTION. Men work in a wheat field in Kansas City, using a McCormick Deering machine. In 1902, McCormick Harvesting merged with four other companies, one of which was the Deering Harvester Company. Flour was sold in 25, 50, or 100 lb. cotton bags. When empty, the bags were recycled for garments or quilts. This postcard is dated 1929. It was sent from Wellington, Kansas to Newton, Kansas, and reads, "Dear Mother: Well am back in Kans again but can't get up to Newton this trip. Will run up on my next trip up here. Love Ancel."

No Ham? Despite the advertisement for Harzfelds', an upscale department store, the postcard sender describes her interest in the availability of food on August 24, 1946. "Had Homer and Jessie out to dinner last nite for baked ham—Probably about the last we will get, what with the OPA back now—We are going out to eat tonite." The writer refers to the Office of Price Administration, established in 1941 to ration scarce consumer goods, fix consumer prices, and set rent ceilings. At the war's end, price controls were gradually abolished.

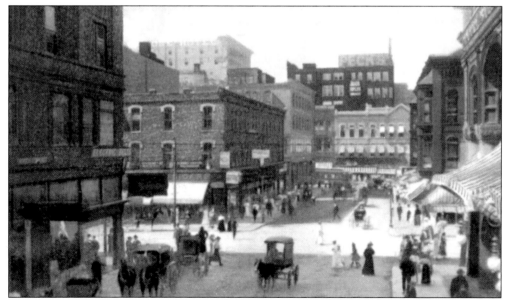

Holiday Treat. In the 1950s, Macy's store did a landslide Christmas trade. Ann Arensmeier tells about her Santa visit, "Mrs. Santa greeted me and asked what I wanted for Christmas. Evidently, she relayed the message by an earpiece, because when Santa placed me on his knee, he already knew what I wanted. When the visit ended, a wrapped gift came down a little slide, a board game or some generic toy for each child. Parents had no choice but to pay a return visit next Christmas."

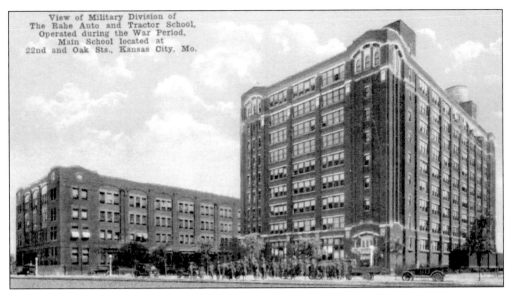

A MULTI-PURPOSE BUILDING. Before the present-day Crown Center, the Rahe's Auto and Tractor School stood on this site. Chances are that visitors have walked in the footsteps of the army personnel who trained at the school during World War I. Housing was also available on the premises, with an array of amenities including shops, gyms, a pool, and even a barbershop. After the war, the building was used for publishing the Kansas City Journal and Milgram's Food general offices.

COMPANIES ON THE MOVE. The Monarch Storage and Mayflower Transit offered storage at two locations, 39th and Main and 31st and Michigan. This postcard was probably printed after 1928 because the home office of Aero Mayflower was not incorporated as a business in the state of Indiana until that year. With new roads opening up customers were increasingly moving by truck rather than rail. To assure fair rates for the consumer, in about 1940, The Interstate Commerce Commission began issuing household goods authority certificates to movers.

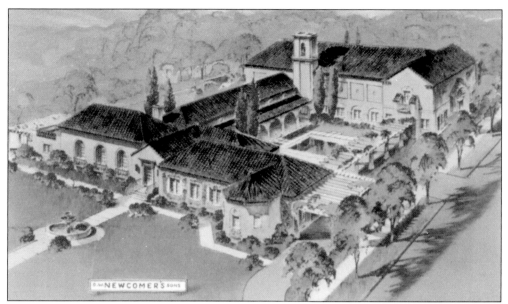

A SASH AND DOOR MAKER. D.W. Newcomer began his career as a sash and window maker in Illinois, but after a request from a friend to make a coffin, his attention turned to providing a necessary service to friends and the community. D.W. Newcomer Undertaking and Livery was formed, and in 1925 David Newcomer Jr. enhanced his father's business by purchasing land close to the Country Club Plaza, and continued to provide Kansas City with their specialized service.

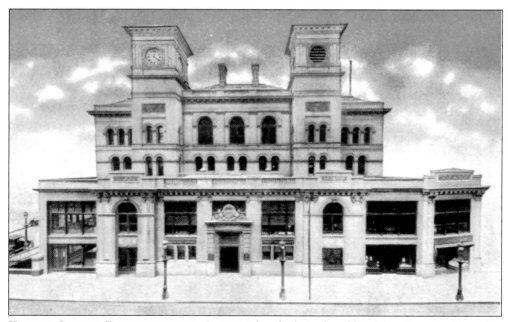

KANSAS CITIANS PURCHASED THE CLOCK. The clock in the old Fidelity Trust Building first rang in the New Year in 1884. It is said the clock was the largest west of the Mississippi and was so precise, people set their watches by it. When President Grover Cleveland visited Kansas City, he addressed a crowd of more than 5,000 people and said, "There is no limit to what a community living in such a place, and actuated by such a spirit, can do."

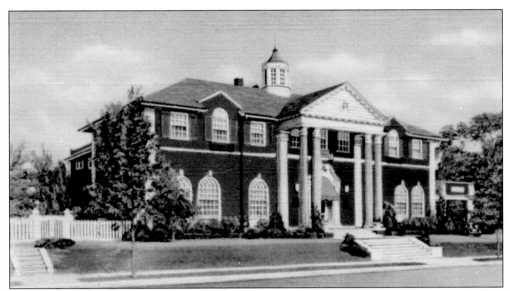

A Dignified End. Stine and McClure Undertakers refer to themselves in this 1944 postcard as "steadfastly maintaining its unique policy of one standard of service, the Highest, to all regardless of financial circumstance." The impressive building of Stine and McClure has palladium style windows and four large columns at the beautiful entryway. Note the car parked under the portico on the side of the building.

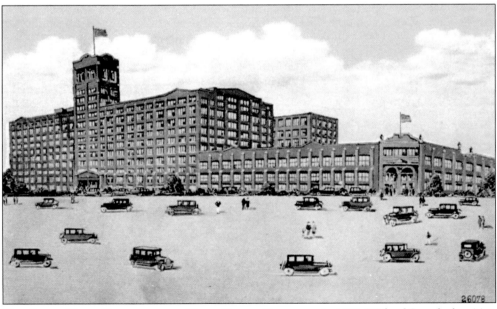

The Store That Began with a Mail-Order Business. In 1886, Richard Sears had a vision for a new company providing a mail-order service to customers. The following year, he hired a watchmaker, a man called Alvah Roebuck, and the two formed the first Sears and Roebuck store. In 1925, Sears and Roebuck opened a store in Kansas City. It was said to be the largest building of its type in the world, comprised of more than thirty-three acres of floor space.

CARBON COPY. The Merchants Association of Kansas City asked for permission to replicate the huge decorative crowns that hung in Regent Street, London for a similar display in Kansas City. Permission was granted and the work began. The cost was $28,000 for nine crowns that were seven feet tall and thirteen feet in diameter. They were so large and heavy, it cost another $41,000 just for the installation. Regent Street and Oxford Street in London have always been decorated beautifully at Christmastime, bringing travelers from around the world to see the wonderful street and department store displays.

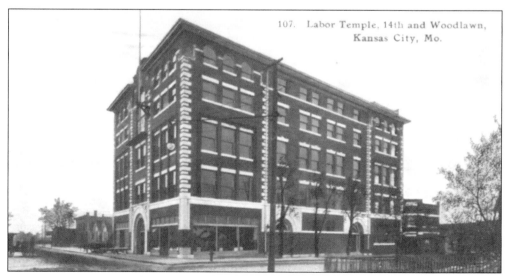

COOPERATIVE UNIONS. The Labor Temple of stone cutters, stone masons, machinists, and plumbers met June 6, 1904, and voted 3,000 to 92 to build their headquarters at Fourteenth and Woodland. A variety of fundraisers were held to boost the coffers at the temple: a Labor Day picnic, raffling of homes, and a bazaar, according to newspaper accounts. The four-and-a-half-story building accommodates many meeting rooms and an auditorium. This postcard is dated 1913, and reads, "How are you . . . came through there last night but didn't stop . . . Nell."

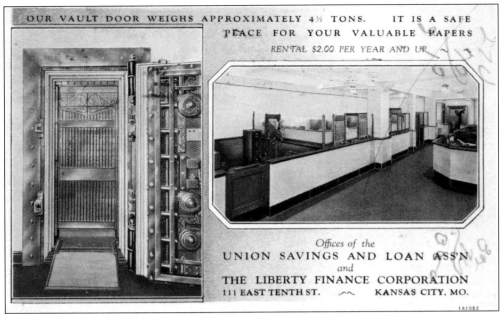

A Safe Place for Your Valuables. The Union Savings and Loan was established in April of 1913. The name changed to Union Federal Savings and Loan when it became a Federal Association in 1963. This postcard is dated January 7, 1932, and reads, "Dear Brother and Sister, We brought her home from the hospital . . . we have a trained nurse with her and will have to keep her for a few days for it might be necessary to give her a hypodermic."

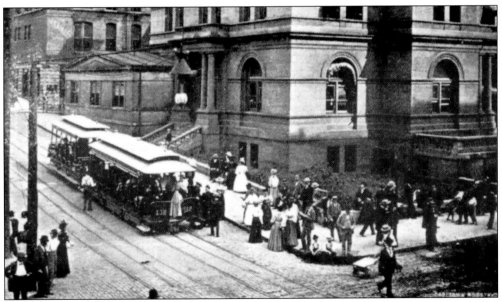

All Points From This Location. The postcard shows a busy intersection by the Post Office at Ninth and Walnut Street in Kansas City. This postcard is undated but shows an open-air streetcar, No. 102, with passengers on board. From 1899 to 1902, there were approximately 600 streetcars in service, charging 5¢ a ride. The postcard states that it was, "At this point the Cable Lines transfer North, East, South and West."

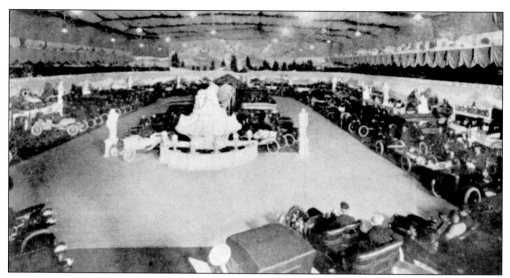

DON'T FAIL TO ATTEND THE SHOW. Men pose in cars as a photograph is taken showing a view of the 1907 Kansas City Automobile Show. The car industry was growing in 1907, with the Ford Motor Company worth one million dollars. In the same year, a Paris newspaper sponsored a car rally that began in Beijing on June 10, destination Paris. The winner, driving an Italia, arrived in Paris on August 10. The car industry continued to grow, with the annual output of automobiles by the United States totaling more than 43,000 in 1907.

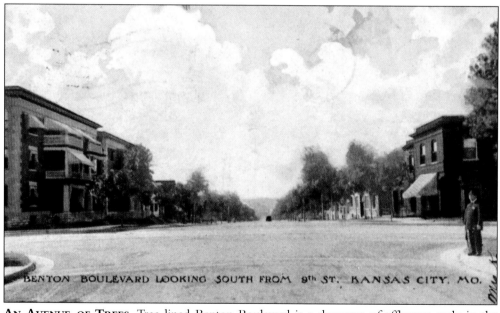

BENTON BOULEVARD LOOKING SOUTH FROM 9th ST. KANSAS CITY, MO.

AN AVENUE OF TREES. Tree-lined Benton Boulevard is a showcase of affluence early in the 20th century. This street is named in honor of the famed Thomas Hart Benton, a 19th century political giant. His namesake and grandnephew became a legendary artist of American historical scenes c. 1950. This postcard is dated 1908, and reads, "Tell Frank I set in the piano box Sat-Eve. Hope you are all O.K."

Eight

HEALING THE BODY AND THE SPIRIT ON THE PRAIRIE
HOSPITALS AND CHURCHES

MOTHER PARISH OF THE EPISCOPAL CHURCH IN KANSAS CITY. Saint Mary's church is a historical landmark that is now dwarfed by construction of Interstates and the Bolling Federal Building. Since the congregation was organized in 1857, it has been a shining example of the courage of the faithful in Kansas City. The red brick building on Holmes has been used since 1888. Church windows are a point of beauty, with their brilliant hues that retain their full color to this day. One window of particular interest is a tribute to the caregivers during the yellow fever epidemic in Memphis, who all died for their efforts of compassion. Tiffany imported Italian marble was used on the altar, and pigmented using a special process developed by an Italian craftsman. He died before revealing this method, there is only one other altar made with this unique design. The first reed organ in Kansas City was brought by rail, boat, and then wagon to Saint Mary's Church.

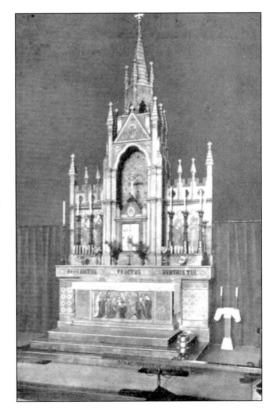

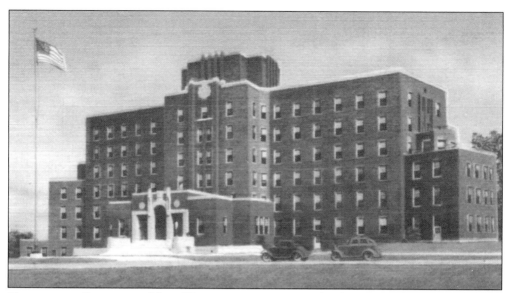

COMPASSION LED TO A NEW HOSPITAL. Compassion for fellow Jewish immigrants from Europe in 1909 led United Jewish Social Services to open the Alfred Benjamin Dispensary at Seventeenth and Locust. In 1931, the Jewish community again responded generously and opened the Menorah Hospital at Forty-Ninth and Rockhill. The hospital boasts of having the latest equipment, graduate nursing staff, and radios in each of the 150 rooms. This postcard, dated 1942, reads, "Why wasnt [sic] you at the club Friday. Call me."

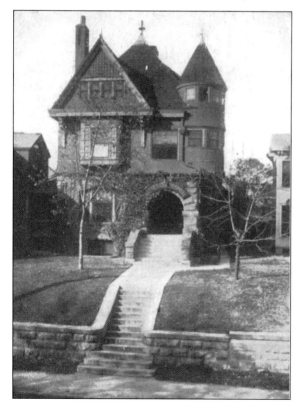

A HOMEOPATHIC HOSPITAL IN KANSAS CITY. Hahnemann Hospital at 912 Tracy Avenue advertised as the "only homeopathic hospital in town with 75 patient rooms." It specialized in children's and women's care as noted on a postcard, dated July 16, 1913, that reads, "Mrs. H, the Drs. say she is doing well this morning ... the operation was very complicated ... removed the womb and ovaries."

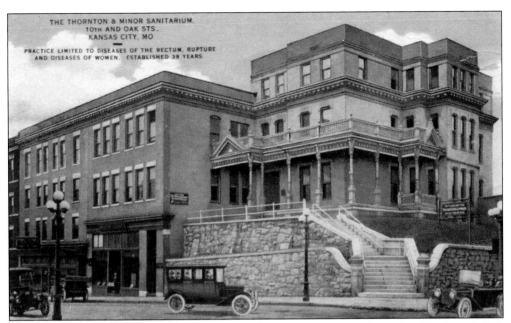

A Note to His Family. The Thornton and Minor Sanitarium located at Tenth and Oak Street specialized in diseases of women; however, this postcard appears to have been sent from a gentleman that wrote to his family January 8, 1932, "Dear Maurine and all . . . we are all right how are you and the cats . . . you and Mama must not work to hard. I have not been out doors today am a going and lay down . . . Papa."

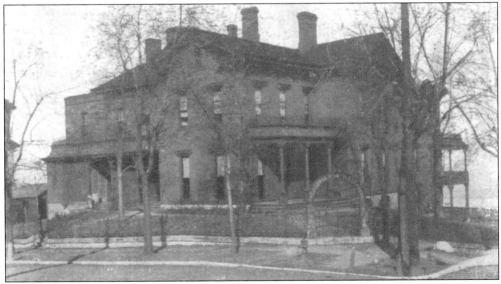

Caring for Girls. The George H. Nettleton Home was the base for the Women's Christian Temperance Union when it opened the home for girls at Independence and Lowell, but it soon changed to include homeless and elderly women too. In 1900, Mrs. George Nettleton offered her home on Quality Hill, landscaped by the famed George Kessler and overlooking the Missouri and Kaw River, on the condition it be named for her late husband. It was moved in 1918 to Swope Parkway at Fifty-second Street.

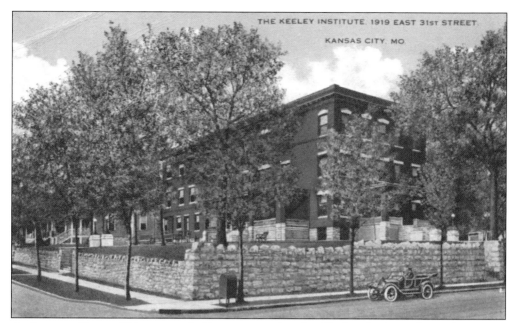

A SIMPLE CURE. This was a bold statement by the Keeley Institute, located at 1815 Independence Avenue, for liquor and opium addiction. It also claimed the success of Dr. Keeley's Gold Remedies. In reading patients' claims, it seems that they lived in elegantly appointed rooms where a large number of patients all seemed happy and confident of a cure. At least two doctors who worked for the railways wrote glowing endorsements in the newspaper *The Kings and Queens of the Range.*

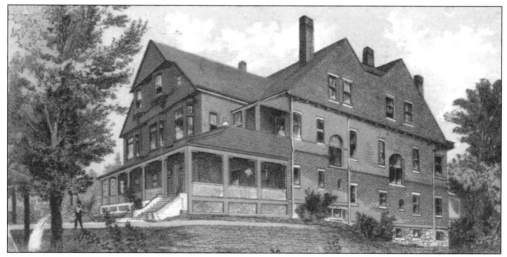

EXCITE NO HOPES OF A CURE. Dr. Coe's Sanitarium, located at 2548 Wyandotte Street, was established in 1888. In 1903, Dr. Wood, a representative of Dr. Coe's hospital, visited a facility in Woodward, Oklahoma, that offered treatment of cold sores, ulcers, salt rheum, diseases of the kidney, and spine paralysis, but specialized in diseases of the eye and ear, correcting cross eyes, and repairing deformities such as bow legs and club feet. A note on the postcard, dated 1911, reads, "Surgical operations performed with skill and success." The sender writes, "Would be pleased to see you at an early date."

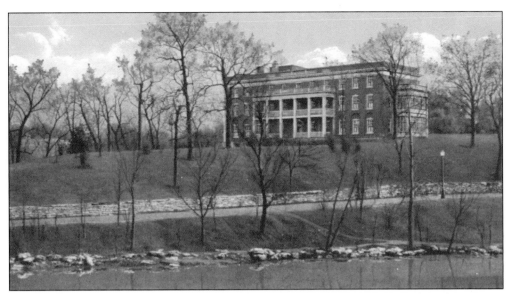

OVERLOOKING THE LAKE. The stately building of Lakeside Hospital was built with attractive red bricks and had white balconies that overlooked Troost Lake. An article in the April 6, 1924 edition of Journal-Post reads, "In the design, which is of Colonial style, a home-like feeling will be carried out by the use of warm colors and residential detail." That Lakeside Hospital would, "feel like home," was the hope of architects Archer & Gloyd, when they designed the hospital for Dr. George J. Conley, osteopathic physician, in April of 1924.

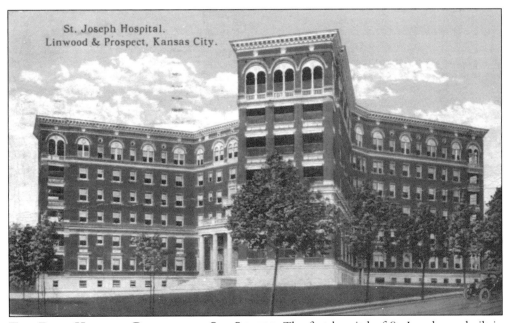

THE FIRST HOSPITAL BEGAN WITH SIX SISTERS. The first hospital of St. Joseph was built in 1874, and had a chapel alongside. This postcard shows the hospital at Linwood and Prospect. It was designed in the shape of the letter "X," having one central building consisting of 133 by 48 feet and then four wings that spread out from the center. This design gave the building the unusual appearance we see in the postcard, dated 1920. Unfortunately, the message is illegible.

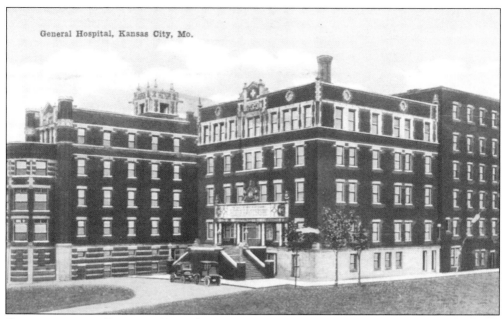

General Hospital, Kansas City, Mo.

CARING FOR THE POOR. In 1908, The Kansas City Star reported that the new General Hospital "is ready now for occupancy, except for a final sweeping out. Treatment there is free to the poor. It costs nothing to be sick at Kansas City's fine new hospital . . . there are quiet rooms for those near death . . . the beds in the 'insane ward' have railings (and) are constructed so that a 'restraining sheet' may be fastened over the top when the patients become violent . . . "

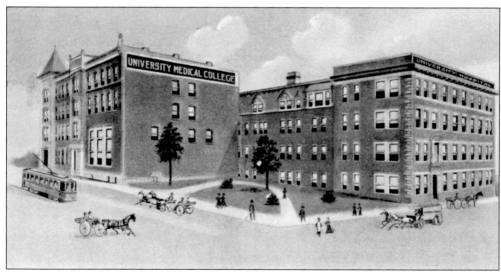

UNIVERSITY MEDICAL COLLEGE

TAKE ME TO THE HOSPITAL. The University Medical College may have been reluctant to name their hospital, since the original building was opened by St. Mary's Church and called All Saints Hospital. In 1886, All Saints experienced financial difficulties and University Medical purchased the property. They renamed it University Hospital. This postcard is dated 1909, and reads, "Rec'd your postal this morning and sad to learn about Clyde R. Please write as soon as you can and tell the particulars."

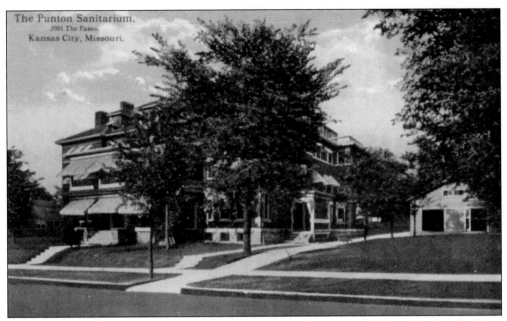

The Punton Sanitarium,
3001 The Paseo,
Kansas City, Missouri.

SERENE SURROUNDINGS. The Punton Sanitarium must have seemed like a blessing for those patients who resided at the home of 3001 The Paseo. It was the second site of the private sanitarium, which treated patients with mental and nervous disorders. It was advertised to be the first such institution west of the Mississippi. This lovely three-story home with window boxes and pleasant surroundings was owned by John Punton.

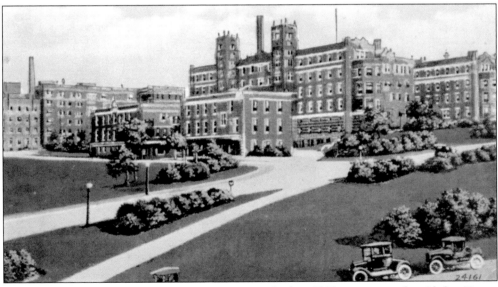

HOSPITAL HILL AN IMPORTANT LANDMARK. In the late 1890s, some people said that Kansas City was only second to Chicago as far as medical institutions were concerned. Hospital Hill has long been an important landmark in Kansas City's medical history. In 1869, a vote was taken and approved for a city bond issue for a hospital, and during that year new medical colleges serving Kansas Citians also opened—the Kansas City College of Physicians and Surgeons and the Kansas City Medical College. The colleges later combined.

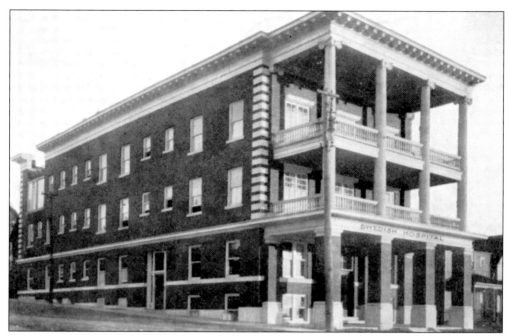

SWEDISH HOSPITAL. There was a healing spirit at the first hospital, located at 1334 East Eighth Street in a renovated residence, opened in 1906. Nearby were the nurses' quarters. The first class of nurses graduated in 1910. In 1911, the Swedish Hospital moved to Thirtieth and Wyandotte, to the former Penn Valley Hospital. By 1921, they renamed themselves Trinity Lutheran to avoid the misconception that they treated only Swedish patients. Later a $201,696 five-story addition was added. This postcard, dated 1911, reads, "I received your card – was glad you remembered me. This is a picture of the building I am in. I remain your friend."

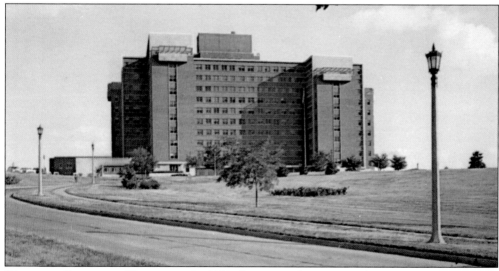

HOSPITAL OPENS FOR VETERANS. In 1952, the veterans' services in the city were centralized at 4801 Linwood. The federal government has offered veterans medical care since the Civil War, but after World War II the need for veterans' care in the metropolitan area rose dramatically. Two wings for research and ambulatory care have been added to the original building.

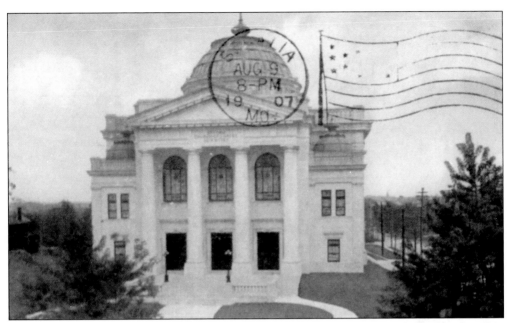

THE CORNERSTONE CAME FROM THE FOUNDING MEMBER. Mary Baker Eddy, founding member of the First Church of Christ Scientist, provided the cornerstone from her New Hampshire home. This postcard is dated 1909, and reads, "Dear Lura, Aunt Ammie wants you all to meet her tomorrow night (Tuesday). She will leave here at 7.20 will get there about 10 I think. Mammy has been trying to get strong so she could come but cannot this time. She will get off at Grand Ave. Love to all and write soon."

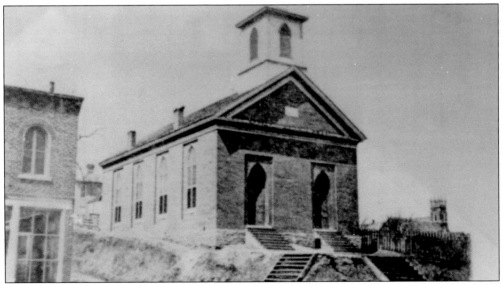

A KIND GROUP OF WOMEN. The Christian Church at Twelfth and Main hosted a small group of women who saw a desperate need and acted accordingly. They met at the little Christian Church at Twelfth and Main Street, and decided on a plan to help the less fortunate in Kansas City. A newspaper described the group's purpose to "relieve the needy and distressed in this new and struggling city."

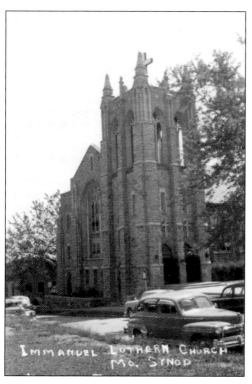

BUILT DURING THE DEPRESSION. A church member notes there was a concerted effort to build the Immanuel Lutheran Church at 4203 Tracy, even though times were hard during the depression and many people were finding themselves financially destitute. The church was completed and dedicated in 1931. A church member remembers the congregation totaled almost 1,500 when its membership peaked in the 1940s.

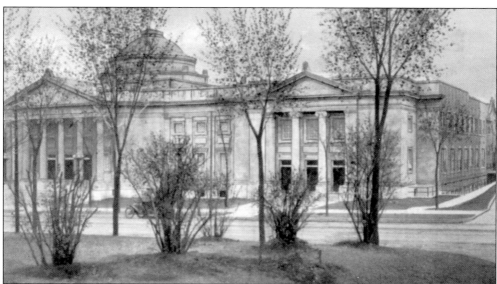

ALMOST A CENTURY OF WORSHIP. The Christian Church at Independence and Gladstone Boulevards began from a generous donation by Mr. Alexander Long, a wealthy lumber baron. As an architect drew up the plans, Mr. Long commissioned Mr. Tiffany himself to design and personally install twelve beautiful stained glass windows in the church, which houses one of the largest and most complex organs in the country. In 1909, Mr. Long challenged the congregation to increase membership. He lost that challenge and, as promised, built a gymnasium with a running track, swimming pool, and educational center.

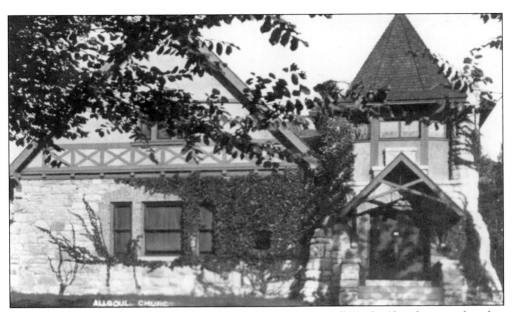

A Last Minute Wish. The sender chose a card showing All Souls Church to send to her friend in Moran, Kansas. The postcard appears to have been written by a young girl, one can see she has written in pencil first, and then covered this in ink. This postcard is dated December 31, 1910, and reads, "Dear Friend, How are you getting long these days. Wish you a Happy New Year. Effie Aber."

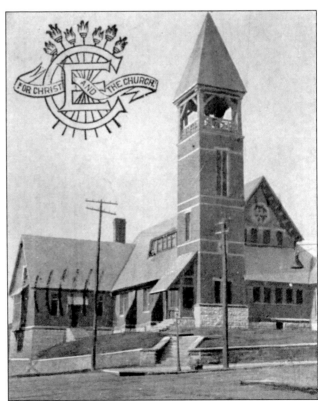

Rich History. The first Baptist Church played an important role in the development of Kansas City. In 1855, ten citizens founded the First Baptist church. Kansas Citians are familiar with some of these men, such as Mr. Wornall and Mr. Holmes, given that street signs around the city are named after them. This postcard, dated 1908, reads, "The Y.P.S.C.E. will be entertained by Miss Stier Friday evening June 26, 1908, 3122 Broadway."

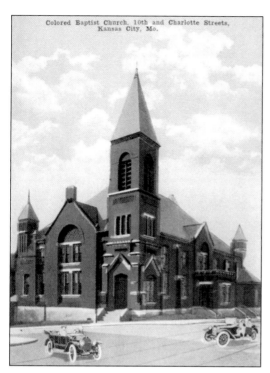

Colored Baptist Church, 10th and Charlotte Streets,
Kansas City, Mo.

BACOTE GRADUATED WITH HONORS.
In 1895, Samuel W. Bacote, the son of
former slaves, became pastor of the Second
Baptist Church in Kansas City. He was
a charismatic man, a scholar, but also a
business-minded individual. Under his
guidance, the debt for the first church was
paid off and he set about building a new
church at Tenth and Charlotte Streets,
seen on this postcard. In 1934, many
black churches had to adjust their service
times around the very successful Kansas
City Monarch baseball team—otherwise
attendance would be low for worshippers.

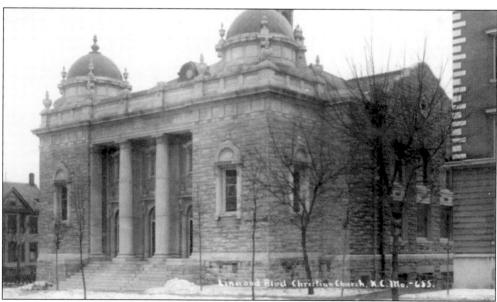

THE TRUTH SHALL MAKE YOU FREE. This inscription is shown above the huge pillars
on the Linwood Boulevard Christian Church. The postcard shows snow on the ground
and trees without leaves, indicating the photograph was taken during the winter. In 1907,
Dr. Burris A. Jenkins became minister of the church. He was known as a liberal minister who
said his church was open to all creeds and denominations, and even encouraged dancing and
movies at his church. There was also a seven-piece orchestra that played on Saturday nights in
the church parlor.

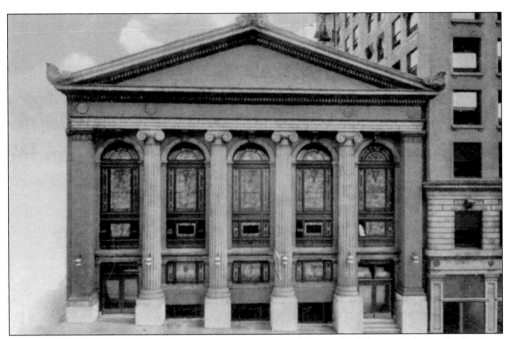

THE MOTHER CHURCH OF METHODISM. Using state of the art building techniques for the time, John McKecknie designed the Grand Avenue Methodist Church using reinforced concrete. This impressive church, located on Ninth Street, was built in Greek revival style and completed between 1909 and 1911. This postcard, dated 1924, reads, "Thursday 11 A.M. Topeka. Just going on, spent yesterday and last night at the Burnaps. Lovely time. On Rock Island R.R . . . Ina."

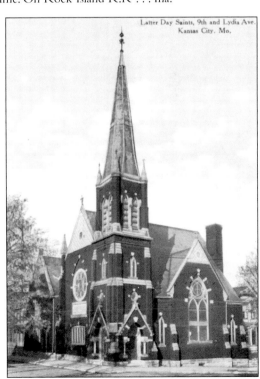

IT WAS ONCE A METHODIST CHURCH. The Community of Christ Archives contains a reference in the Saints' Herald, a church periodical, about the purchase of the Methodist Church on January 22, 1908. "Our new church, bought from the Methodist Church, on Ninth Street and Lydia Avenue, is expected to be opened the first Sunday in February." This postcard is dated 1911 and reads, "Hello Rolland, How is everything. We are sure having some fine weather. I just came from the country yesterday. I will start . . . motoring for Los Angeles, Cal. Tell the folks good life for me. Will write later on. Your friend, Ed. Mason."

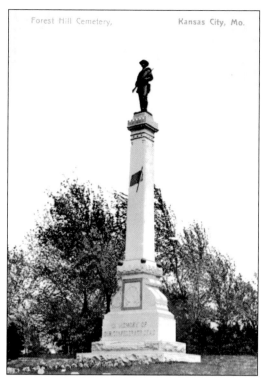

Forest Hill Cemetery, Kansas City, Mo.

IN MEMORY OF OUR CONFEDERATE DEAD. This monument sits in the Forest Hill Cemetery with the inscription on its base indicating it was erected to honor confederate soldiers who died during the war. Originally the cemetery was quite beautiful and hosted over one hundred different species of trees from three continents. One can imagine how lovely they must have been during the spring and summer months. An enterprising farmer, whose land bordered the cemetery, allowed visitors to pick as many flowers as they could carry for 25¢, for use in adorning the gravesides of their loved ones.

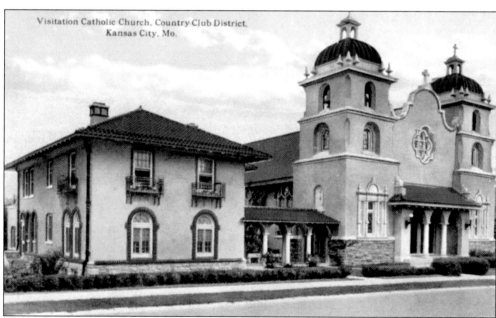

Visitation Catholic Church, Country Club District, Kansas City, Mo.

THE CHURCH WAS BUILT ON FARMLAND. On June 6, 1915, the cornerstone for the Visitation Catholic Church was laid on land previously owned by the McDonald family. Church records tell us that Monsignor McDonald milked cows and rode Mexican mustangs around the farm, and that his father purchased the land in 1886, moving permanently to the region in 1892. Architects Owen and Payson designed the church with a Spanish flair, at an estimated cost of $35,000.

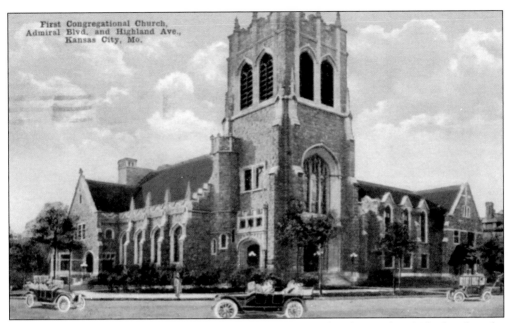

A Splendid Church. In 1866, the First Congregational Church was the ninth church to be founded in Kansas City. Originally the congregation met in a frame building at Tenth Street and Grand for over thirty-five years until the present church was built. It opened on March 1, 1908. This postcard is dated 1920, and reads, "Dear Clara, Your letter and message received and God bless you. Belle was buryed [sic] yesterday. I will write as soon as I am able. Lissa."

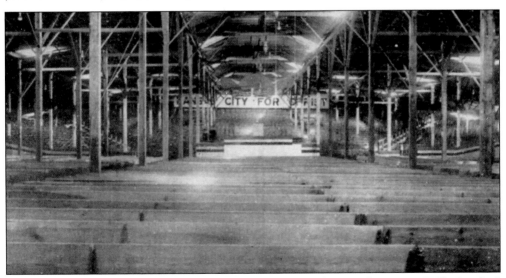

Hitting the Sawdust Trail. William Ashley Sunday, otherwise known as "Billy Sunday," was an evangelist preacher and ex-baseball player who preached his sermons in a canvas and wood tabernacle located at Admiral and Lydia. A congregation of more than sixteen thousand people either sat or stood to listen to the charismatic preacher under a banner that read "Kansas City For Christ." On Sunday's last visit to Kansas City in June 1916, Judge William Hockaday Wallace generously gave the use of his home to Sunday and his entourage, which consisted of approximately forty individuals.

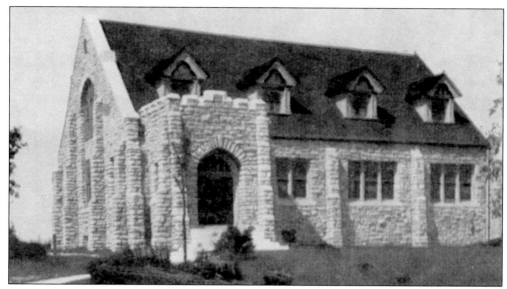

It Began in a Blacksmith's Shop. Church records tell us the Broadway Methodist Episcopal Church, located on Seventy-fourth and Broadway began from humble beginnings. The Sunday school was held in a blacksmith's shop until Mr. Calvin Hewitt donated land, and plans were drawn for the church. This postcard is dated 1910, and was sent by H.G. Humphrey, the first assigned pastor to the church. It reads, "Pres. L. H. Murlin of Baker University will preach 11 A.M. Sunday December 18. Please be present."

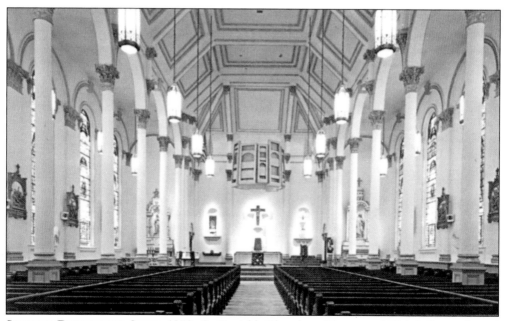

Serving Downtown Since 1873. St. Patrick's Church at Cherry and Eighth Streets hosted the beginning of the St. Patrick's parade. In 1875, a Kansas City Times reporter described the St. Patrick's Parade, "To see an army of men who are not afraid to marry young, nor ashamed to rear large families or robust sons and daughters upon the simple fare that honest labor earns, is to know that the age has not wholly lapsed into the vortex of luxury and vice."

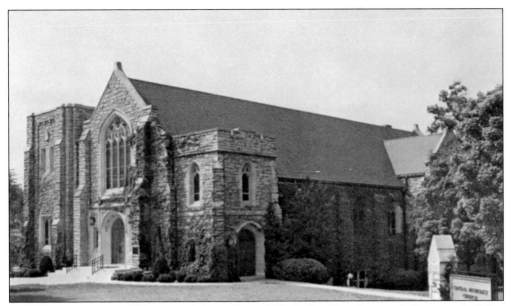

MODEST BEGINNINGS. This postcard shows Central Methodist Church, a stately limestone building built at Fifty-second and Oak in 1939. The church's first gathering was in summer 1844 when members of the Methodist Society gathered in a shady grove near the banks of the Missouri River for a sermon by Rev. James Porter. The congregation's brick building was built in 1852, and was the first of four churches built before this structure became home to parishioners.

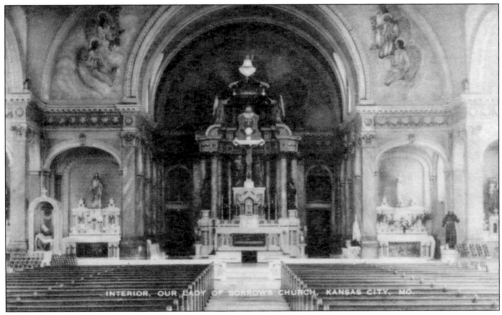

AN ART TREASURE. According to church records, the creative Dante Cosentino added the beautiful frescoes in 1932. It is said that the altar at Our Lady of Sorrows is magnificent, and a Kansas Citian pronounced the bell tower as "a thing of beauty that may well be numbered among the city's art treasures." The bell tower was damaged by lightning in 1944, but was repaired some years later with minor changes.

WHEN WE BUILD LET US THINK THAT WE BUILD FOREVER. These words came from the Kansas City Lutheran Church when the Pilgrim Lutheran Church for the Deaf was instituted in 1941. Often referred to as the "Church of Silence," the chapel was built in 1941 with gifts and memorials that came from eight different states. The generous contributions allowed the plans for the church to go forward and the cornerstone of the church was laid.

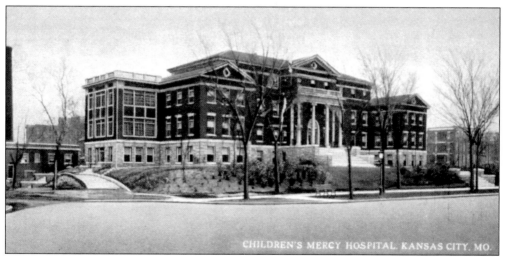

COMPASSIONATE SISTERS. Children's Mercy founders were Dr. Alice Berry Graham and Dr. Katharine Berry Richardson. One crippled child, rescued from the stockyards in 1897, began the sisters' mission to care for children, with financial status of no concern. Always supported by the community it served, early needs were posted on a blackboard outside the first hospital at Fourth and Highland. Although the hospital has moved from it's previous location at Independence Boulevard and Seventeenth Street, the mission remains true to the goals of the Compassionate Sisters.